In Retrospect

NAILSWORTH

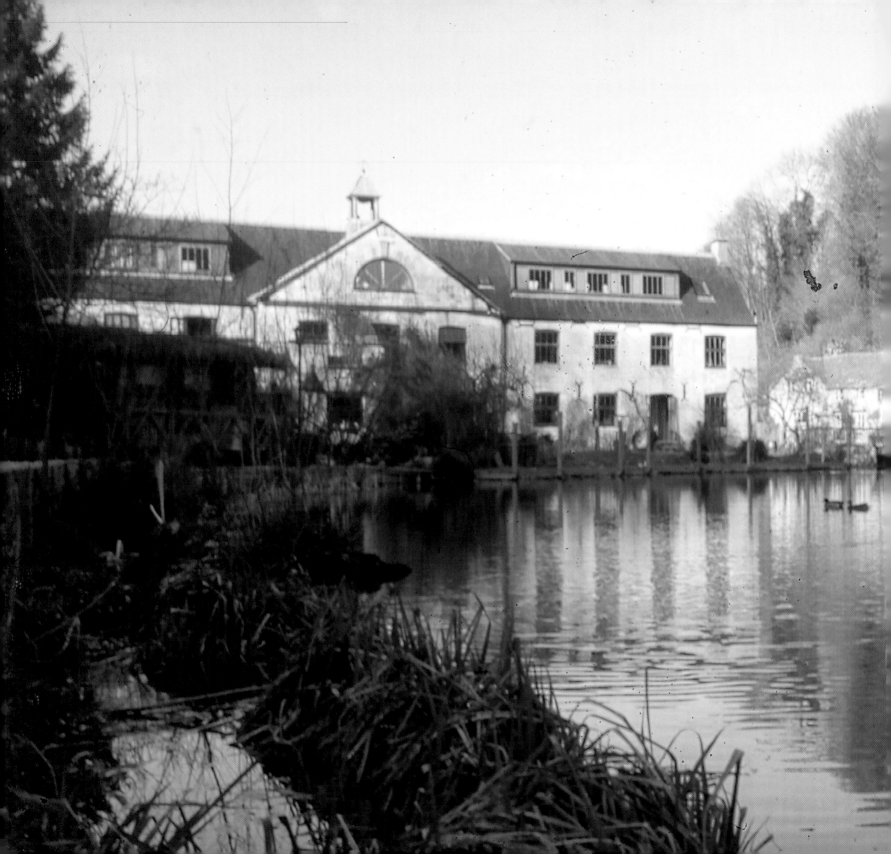

In Retrospect

NAILSWORTH

COMPILED BY HOWARD BEARD

COLOUR PHOTOGRAPHY BY TONY GLOSTER

To all my Nailsworth family
– past and present

First Published 2000
Copyright © Howard Beard, 2000

Tempus Publishing Limited
The Mill, Brimscombe Port,
Stroud, Gloucestershire, GL5 2QG

ISBN 0 7524 2071 2

Typesetting and origination by
Tempus Publishing Limited
Printed in Great Britain by
Midway Clark Printing, Wiltshire

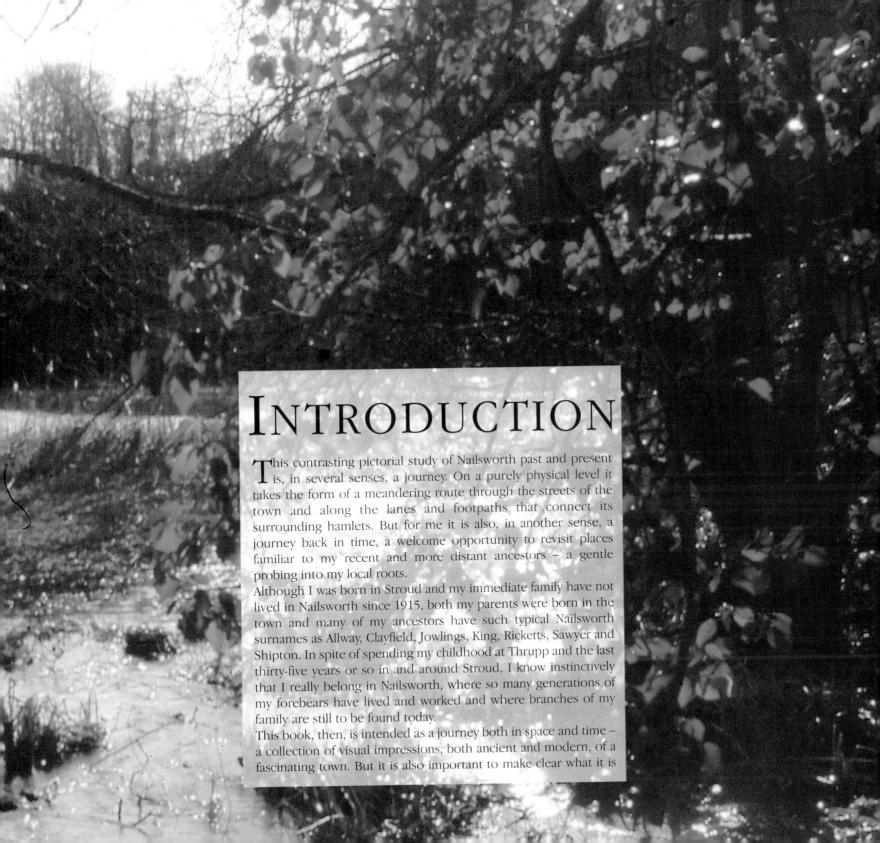

INTRODUCTION

This contrasting pictorial study of Nailsworth past and present is, in several senses, a journey. On a purely physical level it takes the form of a meandering route through the streets of the town and along the lanes and footpaths that connect its surrounding hamlets. But for me it is also, in another sense, a journey back in time, a welcome opportunity to revisit places familiar to my recent and more distant ancestors – a gentle probing into my local roots.

Although I was born in Stroud and my immediate family have not lived in Nailsworth since 1915, both my parents were born in the town and many of my ancestors have such typical Nailsworth surnames as Allway, Clayfield, Jowlings, King, Ricketts, Sawyer and Shipton. In spite of spending my childhood at Thrupp and the last thirty-five years or so in and around Stroud, I know instinctively that I really belong in Nailsworth, where so many generations of my forebears have lived and worked and where branches of my family are still to be found today.

This book, then, is intended as a journey both in space and time – a collection of visual impressions, both ancient and modern, of a fascinating town. But it is also important to make clear what it is

not. It in no way claims the status of a serious parish history, such as A.T. Playne's *History of Minchinhampton*, or Betty Mills' *A Portrait of Nailsworth*. Nor is it in any strict sense a *Then and Now* book. Although images have occasionally been juxtaposed to demonstrate how street scenes or rural landscapes have altered, most photographs merely show how the town once looked, depict the events and personalities associated with a building or a hamlet, or illustrate how interesting and attractive the town is today. *In Retrospect* is simply an invitation to explore, to admire and to appreciate, through the medium of visual social history, a fascinating corner of the Cotswolds.

And what an interesting town Nailsworth is! On the one hand its core consists mostly of Victorian shops and dwellings – the product of that nineteenth-century prosperity which itself resulted from improvements in the local road system and the arrival, in the 1860s, of the railway. On the other hand, surrounding it are many hamlets, composed largely of weavers' cottages and farmsteads, dating from an earlier period, long before Nailsworth had either an ecclesiastical or a civil identity, but consisted of scattered clusters of homes in the ancient parishes of Horsley, Avening and Minchinhampton. The history of Nailsworth is locked into its buildings, its landscapes and the footpaths and lanes that connect them. It is hoped that the early pictures in this book may, in some measure, assist the discerning reader to unravel Nailsworth's past, while Tony Gloster's imaginative and atmospheric colour photographs will lead to a

Downend in early spring.

fuller appreciation of Nailsworth's present day qualities.

In order to explore Nailsworth and its surrounding countryside, the route that the reader is invited to follow begins at Nailsworth's old 'Pepperpot Church'. After leaving the town by the Bristol Road, it follows the Horsley valley to Washpool. Backtracking slightly to take in Downend, high ground at Wallow Green is crossed before Shortwood is reached. Passing The Nodes, after negotiating the stream by a footpath, a lane leads to Newmarket. Continuing into Nailsworth, a left fork passes along The Roller to Forest Green. From Northfields, another path descends to the main Stroud Road at Dunkirk. At Inchbrook the route bridges the line of the old Midland Railway before turning back towards Nailsworth through Theescombe and Watledge where, at the Old Shears Inn, a steep track rises towards the Common and Beaudesert Park School. After descending part-way down the 'W', a left turn at the steepest bend in the road crosses Iron Mills Common towards Longfords. The return route into the town is along the Avening Road. Once back in Nailsworth, most of its main streets, lanes, nooks and crannies are explored. Journey's end is the Parish Church, on this occasion not in its Pepperpot version, but the St George's familiar to the town's present day residents.

This circuitous itinerary may, of course, be dipped into, abandoned at any point or, should the reader wish, entirely ignored in favour simply of glimpsing and contrasting Nailsworth as it once was and as it is today.

The invitation to compile this book was, for me, a double privilege; firstly because it permitted researching a town with a rich and fascinating history and secondly because my brief also allowed me the indulgence of including in it the occasional family photograph and anecdote.

Hopefully, the reader will enjoy the resulting mixture of ancient and modern, general and personal.

Howard Beard
Stroud, Glos

September 2000

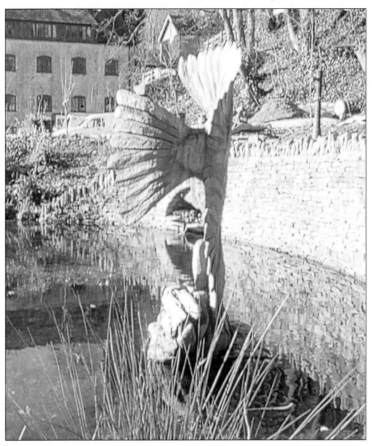

ACKNOWLEDGEMENTS

My thanks to Ann Makemson for permitting the use of images both from her personal collection and from the Nailsworth Archives.

I am also indebted, for their assistance in various ways, to Mrs B. Allan, B. Ashworth, P. Ashbee, D. Binns, J. Caddick, C. Chamberlain, D. Cope, B. Davis, Mr and Mrs K. Fyleman, Mrs M. Gardner, Mrs T. Greening, P. Harris, Mrs M. Holloway, Miss N. Johnson, Mrs H. Martin, Mrs B. Mills, Nailsworth Mills Bowling Club, Peckhams of Stroud, T. Picken, S. Robinson, Mrs W. Robinson, A. Saunders, D. Saunders, *Stroud News and Journal*, H. Shuttleworth, Mrs P. Webb, Miss M. Woodward, R. Woodward and finally my wife, Sylvia, for all her time, patience and encouragement.

NAILSWORTH
In Retrospect

Nailsworth, in its position at the convergence of several valleys, can be seen from many hilltop vantage points and a variety of angles. The view from the south is one of my favourites. St George's and the Town Hall both stand out prominently and in the foreground are two of Nailsworth's millponds, the further of which, obscured by trees, served for many years as the town's swimming pool.

From the top of Tetbury Lane, most of Nailsworth is hidden below the curve of the hillside. The terraced cottages of Watledge disappear off to the left and The Hollies, close to the 'W', shows prominently. Beaudesert Park School lies among trees on the horizon.

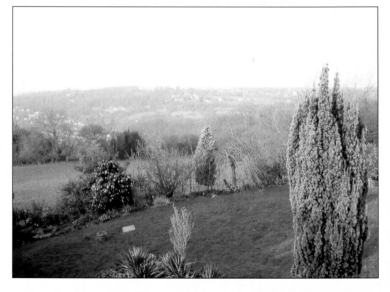

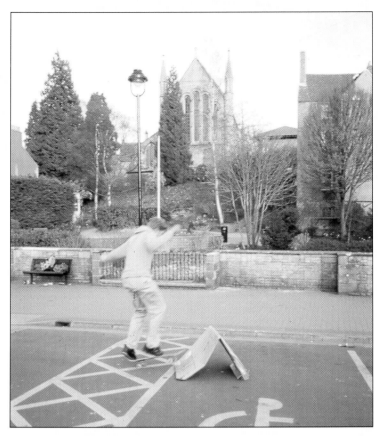

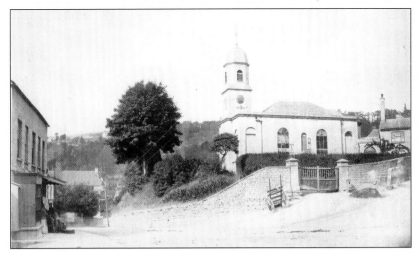

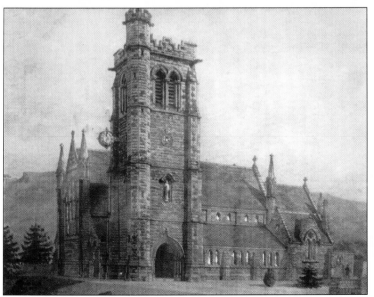

Between Old Market – a favourite haunt of youthful skateboarders – and St George's Church are the Mortimer Gardens.

The predecessor of the present-day St George's (seen above) was known as the Pepperpot Church, for obvious reasons. It was erected in 1794 and, until the town became an ecclesiastical parish a century later, was merely a chapelry of the mother church at Avening. This is probably one of the earliest photographs taken in Nailsworth and dates from around 1873. Note Day's Mill on the left in the background. Before its right hand portion was demolished, this building almost blocked the route of what is now Fountain Street.

It was envisaged, when the Pepperpot Church was taken down in the late 1890s, that its replacement, on the left, would have a much larger nave with aisles and a tower; also two clocks so that, as people said, Nailsworth would have no excuse for not knowing the time of day. These objectives were largely achieved although, for reasons both of cost and stability, the tower shown on the left in this artist's impression was never built, which explains why St George's has such an unexpectedly solid entrance porch. As we shall see later, a clock was installed in a separate wooden structure on the bank on the lower side of the church. It became very much a Nailsworth landmark. The chancel was not erected in its present form until 1939.

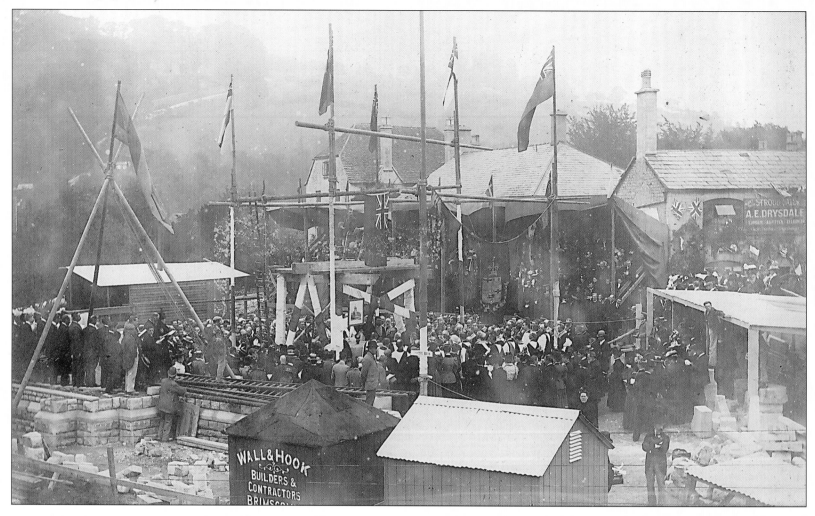

The stone-laying ceremony for Nailsworth's new church took place on 6 October 1898. The occasion was made additionally auspicious by being linked with the consecration of a new Masonic Lodge in the town – the Royal York Lodge No. 2079. The event was further enhanced by the presence of Sir Michael Hicks Beach, Provincial Grand Master of Gloucestershire and Chancellor of the Exchequer, who was invited to perform the stone-laying. Interestingly, since the ceremony took place with full Masonic honours, the Bishop of Gloucester wrote to the vicar of Nailsworth in the following terms: 'I am not a Mason, but I have no objection to Masonic honours. They were used at the stone-laying of the nave of Bristol Cathedral'.

The foundation stone itself, we are told, weighed two and a half tons and came from Niblett's Quarry at Minchinhampton. In a cavity beneath it were placed current coins of the realm, local newspapers and an account of events leading up to the building of the church. It was stated that, when complete, the new seating capacity of the building would more than double that of its predecessor. The bill for its erection would be £4,820.

The events of the day included a cold luncheon at the Police Court. Flags and bunting surrounded the platform where the stone was laid, a hymn was played on an American organ and the Masons, it was reported, looked quite splendid in their regalia complete with white gloves.

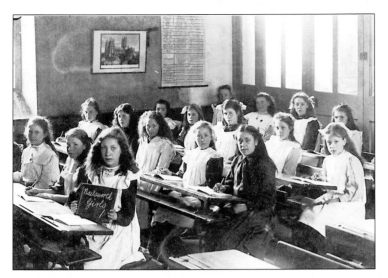

Close to the church is the former Girls' School. In Nailsworth, a century or so ago, the Anglicans oversaw education for girls, while the Boys' School, at the top of Spring Hill, was under the denominational control of the Non-Conformists. The Girls' School, called the Acorn School today, is now co-educational and is run along Steiner principles. On the right of the alert group of Edwardian pupils in the photograph is Jessie Bruton, a member of one of Nailsworth's longest-established families. The chart on the wall is of interest since it lists a lengthy catalogue of illnesses and accidents to which pupils might fall prey (and the remedies which might be applied); they include chapped hands, ringworm, swallowing coins and poisoning!

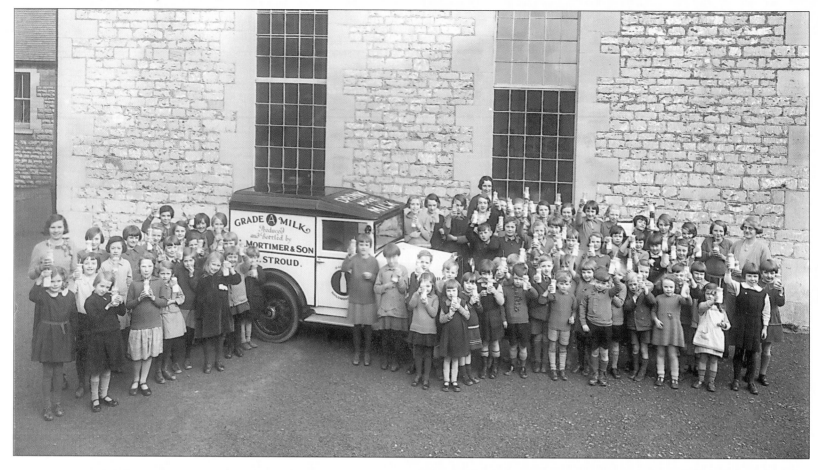

This photograph of children by the Girls' School is thought to show the introduction, around 1937/38, of the school milk system.

In the picture of the Nailsworth and Horsley Child Health Clinic's 1960 Christmas party, held in the Girls' School, Nurse Weigart inspects some of her young charges. The lady standing second from the left is Mrs Billy Harris, who was responsible for organizing the event.

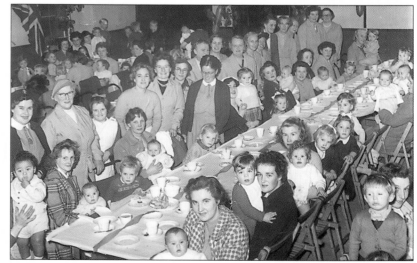

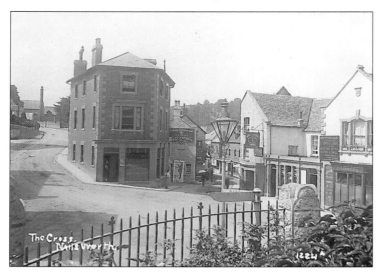

The Cross. Nailsworth.

This well-focused and thoughtfully composed picture of The Cross shows Nailsworth photographer E.P. Conway's work at its very best. It was taken from where the War Memorial now stands. The red-brick building to the left of centre was put up a century or so ago as a branch of the Wilts and Dorset Bank. It later housed a sweet shop and a laundry before its demolition in the interests of better vehicular visibility. Up the Bath Road in the distance can be seen the chimney stack belonging to Nailsworth Brewery. However, what is unusual about the photograph is that it can be dated very precisely. Beyond the now-vanished finger post and gas lamp may be seen a display board advertising the Mid-Gloucestershire Historical Pageant of Progress which took place in early September 1911 at Fromehall Park in Stroud. To the right is The Crown Inn, which was empty for a while, but has now happily re-opened for business.

Without the buildings which formerly stood on its left side, the entrance to Market Street, as seen from The Cross, is more open and easier for vehicles to negotiate.

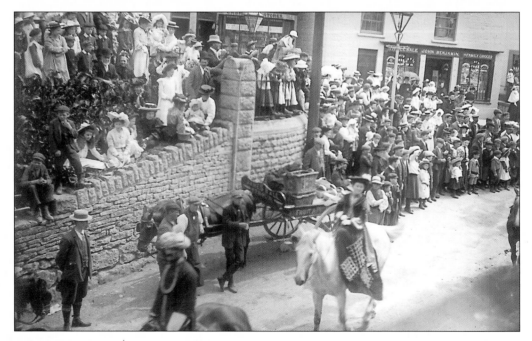

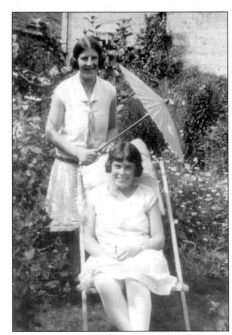

Top left:

At The Cross, the two shops on the left have both housed businesses for at least a century and a half. The Subscription Rooms beyond, formerly a cinema and now the Boys' Club, were built in 1852. This was, in the early years, the home of the much respected Mutual Improvement Society.

Bottom, far left:

Taken from an upstairs window of the ironmonger's shop opposite the church in Fountain Street, this photograph shows the spot from which E.P. Conway stood to take his picture of Market Street. Crowds at the entrance to Church Street and on the adjoining bank watch a pre-First World War carnival procession on its way from the field at the bottom of Tetbury Lane where marshalling traditionally took place. A fruit and vegetable cart, owned by James Ball of Stroud, can be seen near the wall. The picture has been developed from a recently discovered group of Nailsworth glass negatives.

John Benjamin's shop is in the distance. Its stone cellar was rented as a slaughterhouse by my great-uncle, Cecil Weight of Forest Green, of whom we shall discover more later. My cousin, Winifred Robinson, recalls that Cecil's nephew, her brother Walter Beard, used to earn 6d each Saturday morning for washing out the cellar after his uncle had completed his work. In addition to this modest monetary reward he was also given a pound of sausages, which determined the Beard family's regular choice of Saturday lunch.

Bottom, left:

John Benjamin's two daughters, who died quite recently, were well known in the town. In this photograph, taken around 1930, Joan holds the sunshade for her sister Helen. From around 1923 to 1966 the sisters ran one of Nailsworth's many small private schools. They also loved tortoises and kept several as pets over the years.

Right:

The most distant of the row of houses in Bath Road was home to the photographer E.P. Conway, mentioned earlier, who recorded, through his postcards, so much of Nailsworth's history.

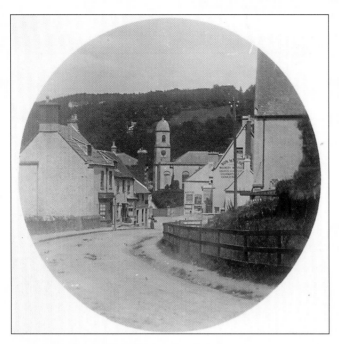

It may just be the appeal of its circular format, but this is one of my favourite Nailsworth photographs. It seems to suggest such an inviting entry into the town and must have been taken before 1898, since the Pepperpot Church is visible in the distance.

The Bath Road, as it enters Nailsworth from the south, is lined on its right side by Victorian and Edwardian villas, the Subscription Rooms, a few older buildings and the church. Properties constructed in Stonehouse brick invariably post-date the arrival of the railway in the late 1860s. After passing through some twenty-five miles of open country since leaving Bath, a traveller arriving in the town for the first time must feel he has reached a place of some significance, with buildings of both historical and architectural importance.

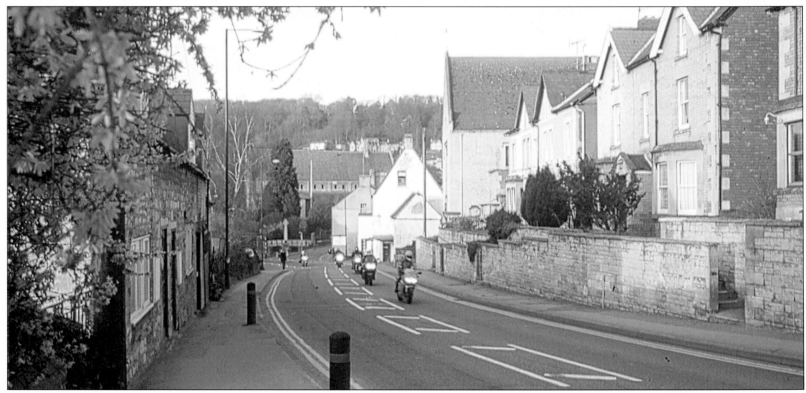

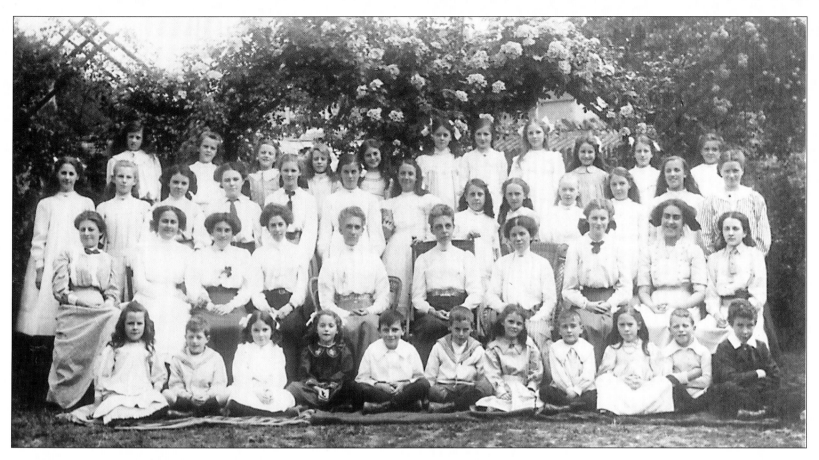

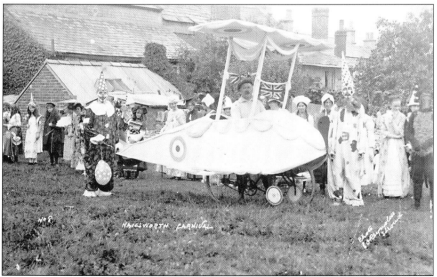

NAILSWORTH CARNIVAL

Yet another private school patronized by Edwardian Nailsworth's upper middle class was Stoneleigh House. Run by the Misses Hodges at a house in the Bristol Road opposite the Town Hall, this was a single sex school catering for a rather more extensive age range than most similar institutions. My mother spent a couple of years here before transferring, at the age of thirteen, to Stroud Girls' High School. Her recollection was that the curriculum at Stoneleigh House leaned more towards the arts than mathematics and science.

Nailsworth has always enjoyed its carnivals. There was a particularly good example in 1920 and this was one of its more enterprising entries. Considerable effort must have gone into the construction of the aeroplane, built around the bicycle frame, and how proud of his handiwork its creator looks. The picture was taken behind the houses which front the Bath Road.

Looking in towards the town centre along the Bristol Road, the Town Hall is on the left. The building on the right with the fine metalwork was the Misses Hodges' school.

The Town Hall has an interesting history. Built in 1867, it started as a Baptist Chapel, the result of a doctrinal dispute which led to a section of the congregation of Shortwood Chapel leaving the mother church. In 1910 the building was taken over by the Methodists, assuming its present function in 1947. The photograph, taken in 1925, is of members of the Methodist Wesley Guild. The gentleman with the violin is Edmund Bathe, well known as a local bill poster and chimney sweep. Second from the left in the middle row is Winifred Robinson, who owns the picture.

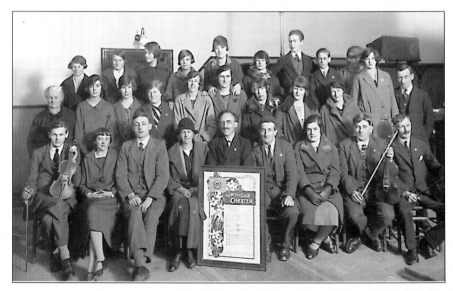

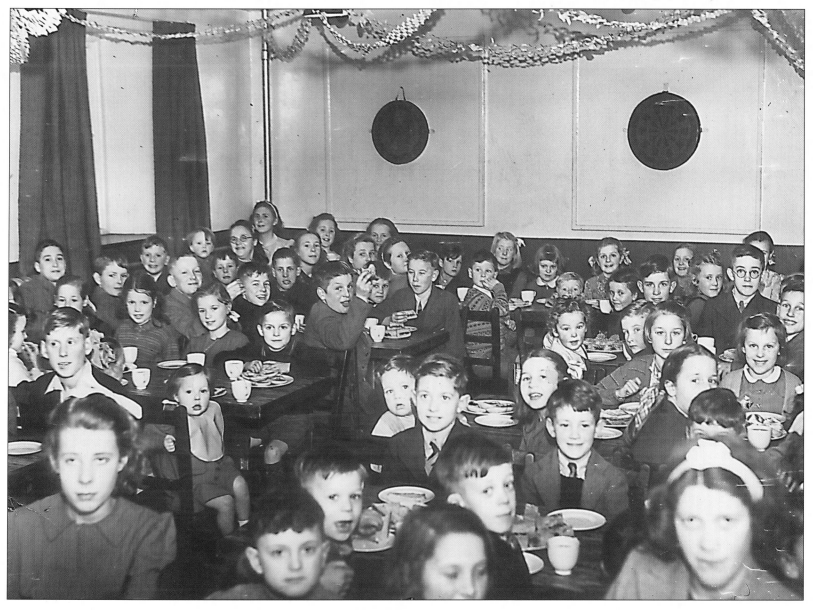

Taken in the Town Hall, possibly in the 1950s, this photograph is of a group of children enjoying a tea party. The occasion is, as yet, unidentified, in spite of a plea for information through the pages of the local press.

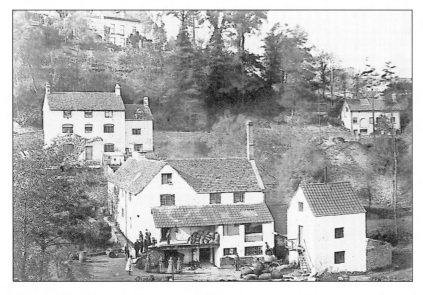

In this view across Nailsworth's rooftops, taken from a spot near the Town Hall, it is possible to contrast what survives of early Nailsworth with more recent building development.

The Gig Mill, on the lower side of the Bristol Road, survives largely unchanged today, more than a century after this view was taken. What makes the picture important, however, is that it shows it as a working flock mill. By 1910 the building's use had changed and it housed a fellmonger's business, where hides were prepared for conversion into leather. It is still used for industrial purposes today. Behind the mill, and to the left, is a house where a family called Slaughter lived: the right hand portion of this building was a small shop. Above, on the hill, is Rockness House, which contains some finely painted doors, the work of Matilda Clissold whose home it once was.

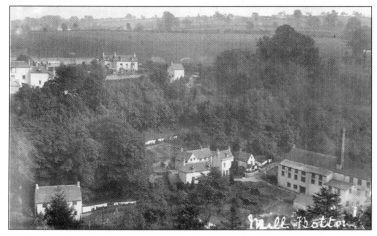

The stonework of Rock Cottage, set high on the hilltop at Rockness, has many interesting features, as the doorway and window illustrate. It was formerly occupied by a stonemason who worked on Woodchester Park Mansion, which explains the quality of the carving.

In the 1890s Millbottom Mill was used for grinding corn by Edward Benjamin, whose shop was in Market Street. By the early years of the twentieth century the ponds upstream, by Horsley Mill, were being run as a trout farm by Midland Fisheries. In recent times Millbottom Mill, renamed Ruskin Mill, has been developed as a Further Education Centre for young people, incorporating an organic cultivation project. The picture, by an as yet unidentified photographer, dates from around 1910 and was taken from Rockness.

Pike Cottage, on the junction of Pike Lane with Horsley Road, was of course once a turnpike house, controlling a gated section of the public highway.

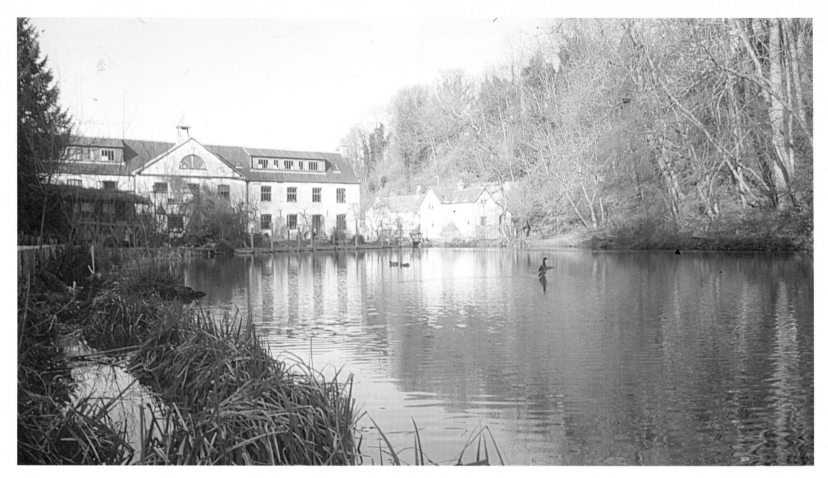

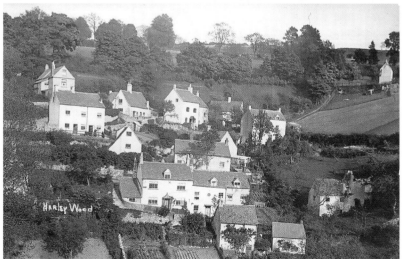

Harley Wood

Ruskin Mill has a particularly attractive appearance when viewed from the south.

Harley Wood is surely one of Nailsworth's most picturesque hamlets, with its tiered weavers' cottages clinging to the hillside above the millpond. In former times, however, in spite of its apparent rural tranquillity, Harley Wood was considered a 'rough' area: police were reported to patrol it in twos, and some of its children went barefoot. An amusing story has been passed down of a resident whose log pile was being systematically and mysteriously robbed. In order to discover the identity of the thief, the victim apparently drilled out a log, filled the cavity with gunpowder, then waited for the ensuing explosion to reveal the culprit!

Early spring sunlight plays on the trees and cottages of Harley Wood.

James Brain, lime merchant and haulier, ran a small business at Harley Wood during the last part of the nineteenth and the early years of the twentieth centuries. A native of Wiltshire, James is seen in this fine social history study aboard his delivery cart somewhere around 1910.

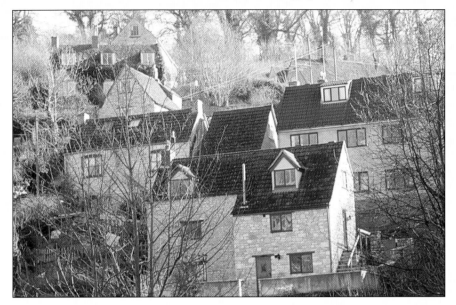

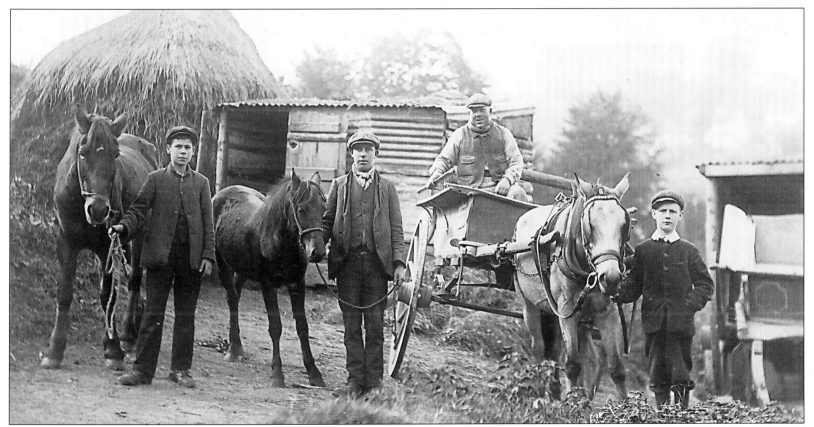

Across a foreground of lawns and gardens, recent developments in the pond system of the old trout fisheries can be glimpsed.

The Trout Fisheries have been a familiar feature of the Horsley valley for well over a century. Winifred Robinson – whose father, Frederick Beard, lived not far from the ponds – remembers, on Sunday evening walks, watching the fish jumping. In the centre of the picture a small building can be seen. This, I am told, was a grinding house to which local people, such as Sid Hawkins, took animal carcasses to be rendered down into bite-sized portions suitable for feeding to the fish.

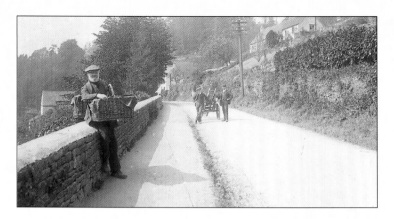

Nathaniel Dyer, not to be confused with his earlier namesake, of whom more will be discovered later, was an itinerant bread and cake seller, familiar to local people. He was born about 1840 and, at the time this charming photograph was taken, would have been nearly seventy years old. He seems to have been the sole member of his family employed as a hawker: his unmarried brother worked on the land and one of his sons was a carter.

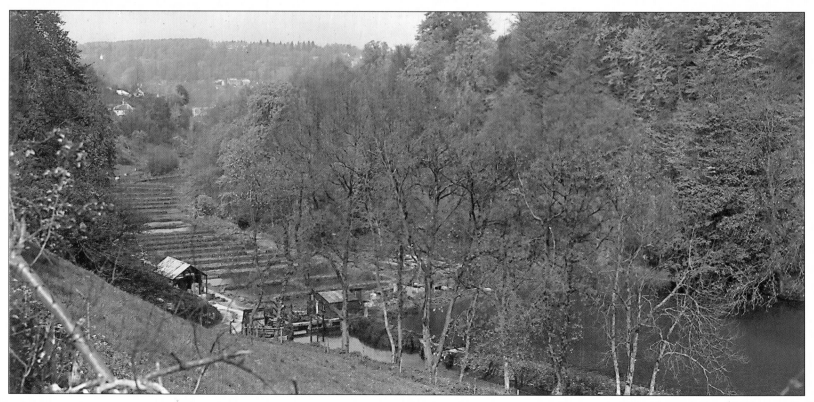

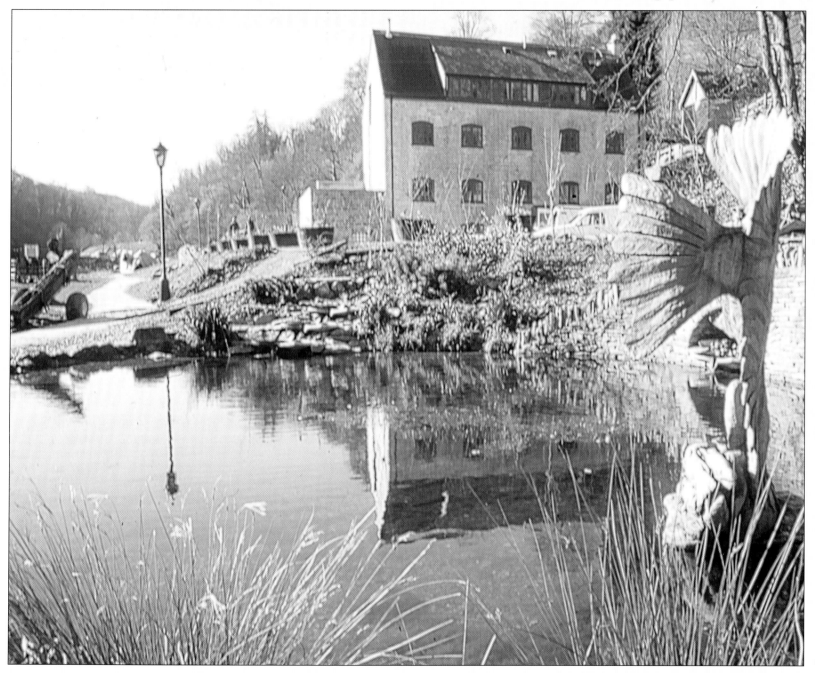

A modern sculpture of a mountain eagle overlooks a pool in which Horsley Mill is reflected.

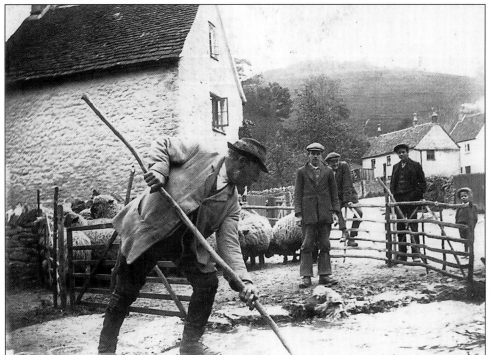

Top, far left:

The footpath which follows the course of the stream down the Horsley valley is a favourite haunt of walkers, both two and four-legged.

Top left:

A network of pathways connects the cottages on high ground at Rockness with Horsley Road below.

Bottom left:

The sheep washing which gave Washpool its name has taken place for generations in this hamlet. Grooves in the masonry of the stone-lined pools still exist, proving where boards were once inserted to raise the water level before washing could commence.

Top right:

On a February day at Washpool, clusters of snowdrops sprout from banks and smoke hangs over cottages.

Top, far right:

The top of the hill that leads up into Horsley is as far as our route south takes us. The War Memorial was dedicated on this site, thought to be the original position of the ancient village cross, on 17 July 1921. It has since been re-positioned in a recess of the churchyard wall. The unveiling ceremony was performed by General Sir Francis Howard KCB, of Painswick. The Horsley Brass Band accompanied the proceedings.

Bottom right:

Horsley Court was built mainly in the early part of the nineteenth century, although it has internal features dating from a hundred years earlier.

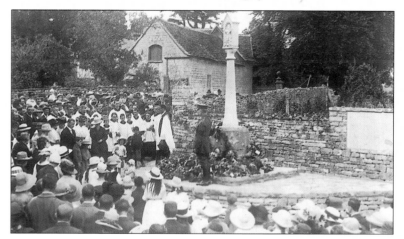

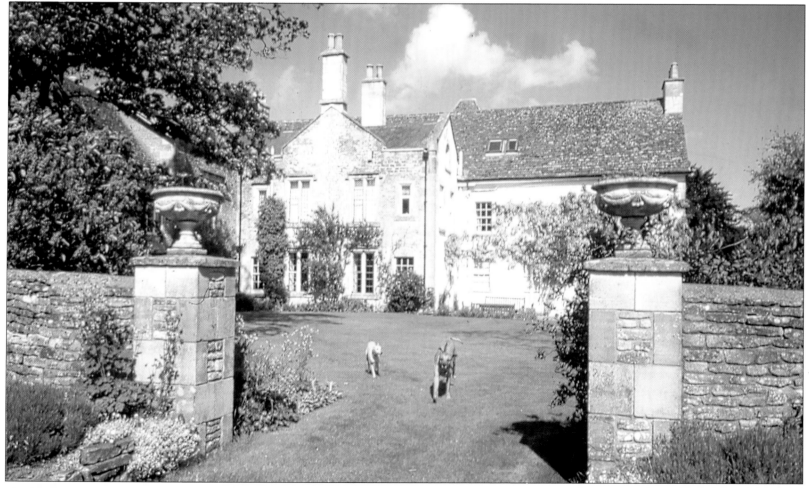

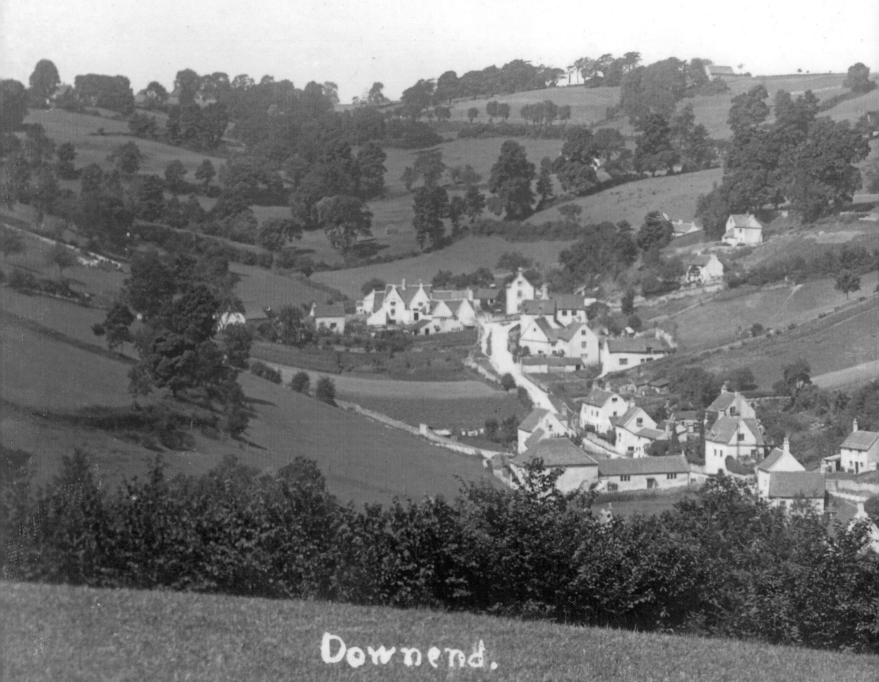

Downend.

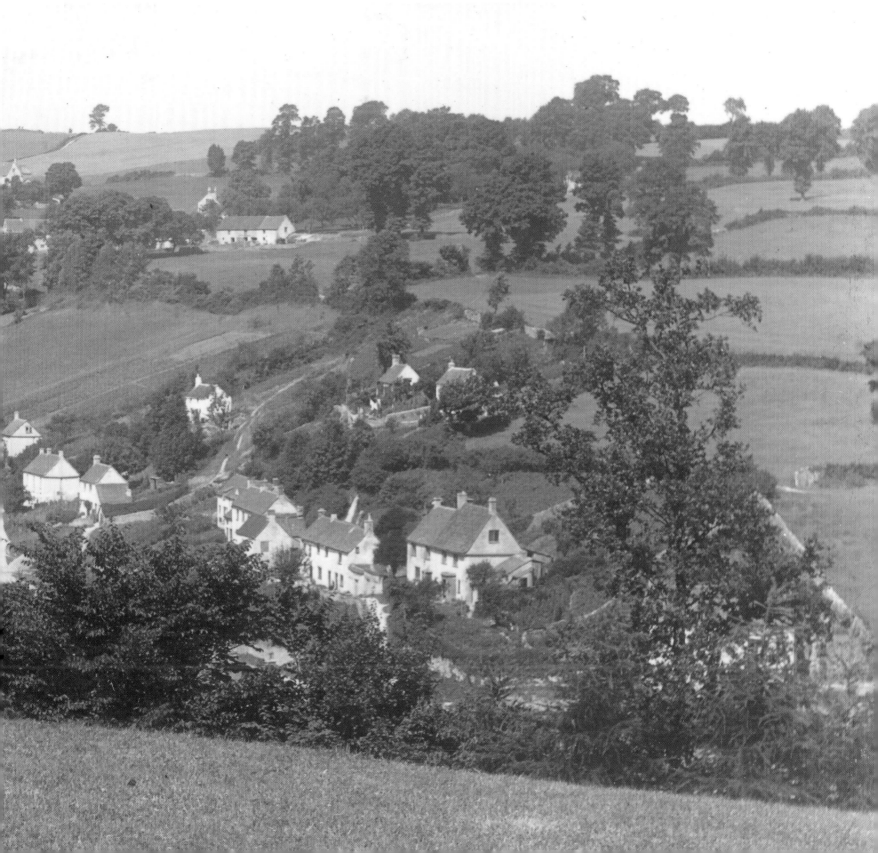

Previous page:

Downend is a most attractive hamlet. In this picture, taken around 1910 from a vantage point across the valley near the Bath Road, E.P. Conway has successfully captured some of its charm. The hamlet once contained a public house, the White Hart, and a small Methodist Chapel. Later building development has been fairly modest and has not diminished Downend's appeal.

This page:

Downend contains several good examples of period buildings, both nineteenth century and earlier.

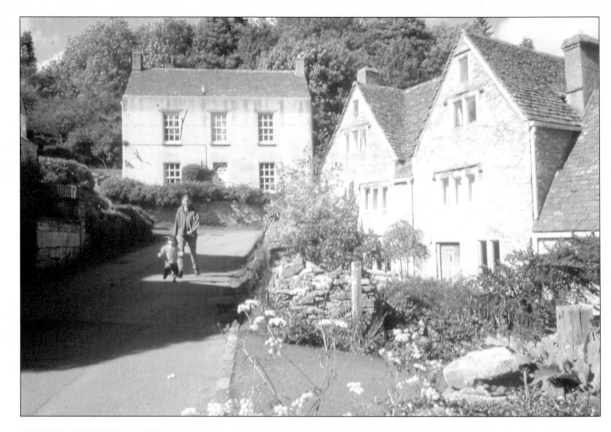

Tickmorend House, situated on the steep hill leading up from Downend to Wallow Green, is the home of Roger Franklin, a long-time campaigner against nuclear weapons, and is a nuclear-free zone.

A cottage at Wallow Green displays a profusion of early summer blooms.

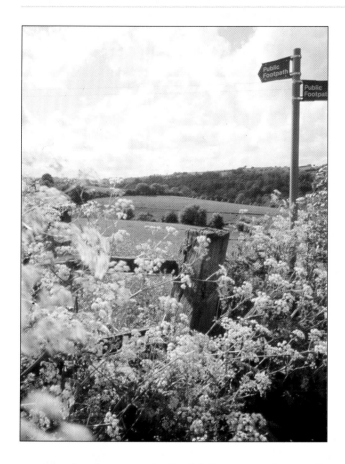

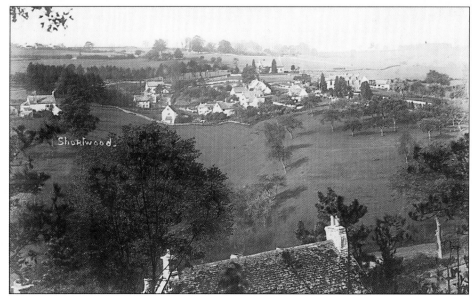

Beyond a foreground of wild flowers and unspoilt countryside the Nympsfield wind turbine stands sentinel.

It is curious to recall that Shortwood was, during the late eighteenth century, the hub of one of the country's largest and most flourishing non-conformist communities. Under the pastorate of the Baptist minister, Revd Benjamin Francis, worshippers would travel from many miles around to fill the Meeting House for Sunday services. In 1837 the chapel was rebuilt and, in 1881, it was decided to move it to a site in Newmarket Road, closer to the centre of Nailsworth. Sadly, because the chapel registers are woefully incomplete before 1800, I share with other local amateur genealogists the problem that several of my ancestral surnames, such as Clayfield, Jowlings, Ricketts, Sawyer and Shipton, are not traceable back through the eighteenth century.

Right:

Behind Shortwood's cottages is the old Baptist graveyard and beyond that the woods through which Nympsfield may be reached.

Below:

Headstones in Shortwood Baptist graveyard, mostly still clearly legible, lean at odd angles. My great-grandfather Allway's memorial still stands guard over the family plot. His poorer ancestors lie nearby in unmarked graves.

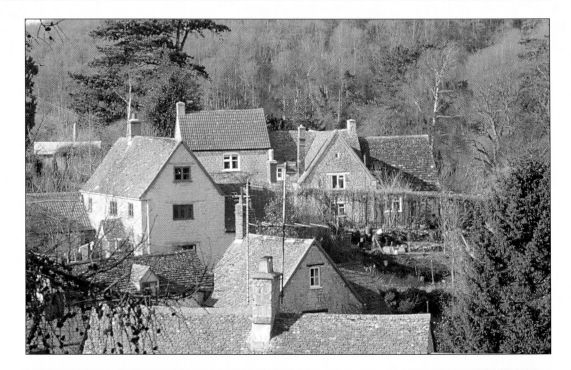

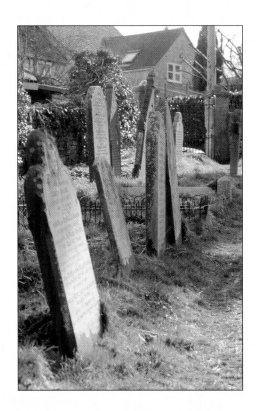

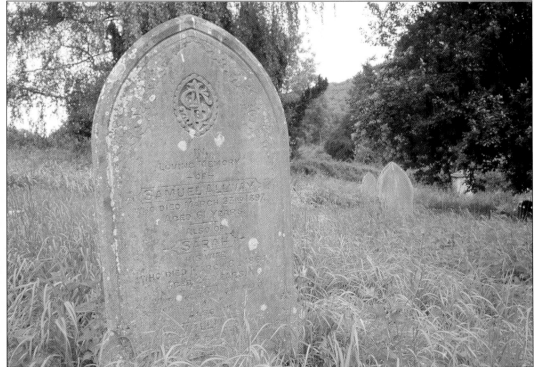

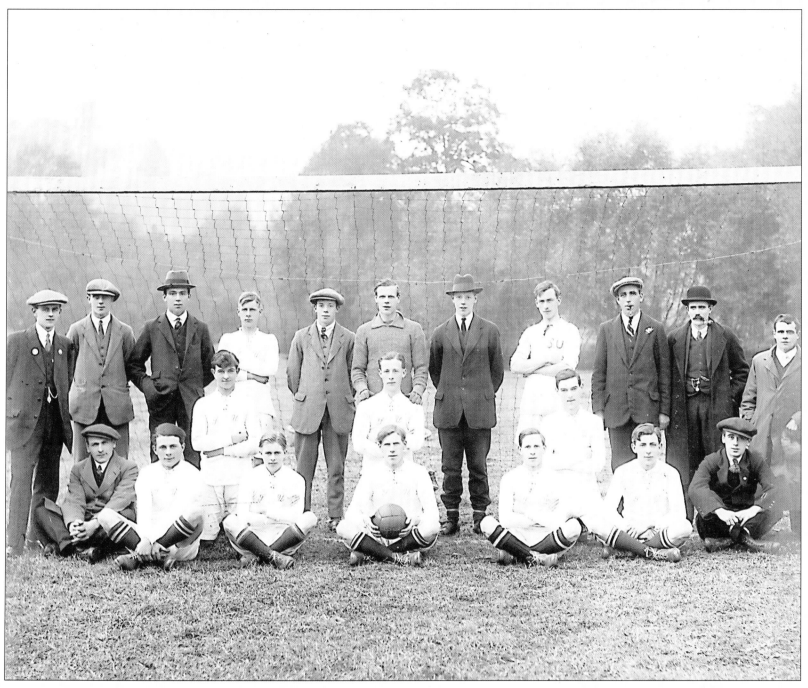

Shortwood has boasted a football team for generations. The one shown here, season 1919-1920, includes such distinctive local surnames as Coates, Farmiloe, Grant and Heaven.

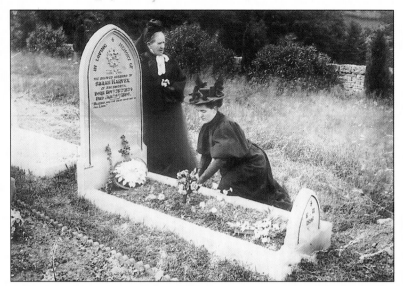

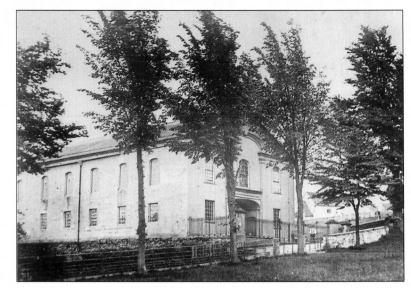

Above left:

The portion of Shortwood Baptist graveyard made available for burials by the removal of the chapel building in 1881 was soon used up. Further land, still in use, was given by Isaac Hillier. In 1896 Enoch Harvey died. He had farmed land near the Bath Road and was buried in the lower part of the graveyard. In this unusual study of family mourning his widow, Sarah, stands by what is clearly a newly-erected headstone, while a younger woman – he had at least three daughters, all tailoresses – tends the grave.

Above right:

Until its demolition in 1881, Shortwood Chapel stood on the level ground below its large graveyard, which is still in use. As the photograph taken around 1880 shows, it was a fine building, although architecturally perhaps not quite a match for its imposing successor. In the graveyard many well-preserved monuments survive, dating back almost to the Chapel's foundation. Several show interesting features and include copper plates, oxidized but clearly legible – such a useful aid for family historians in an area where limestone erodes so rapidly.

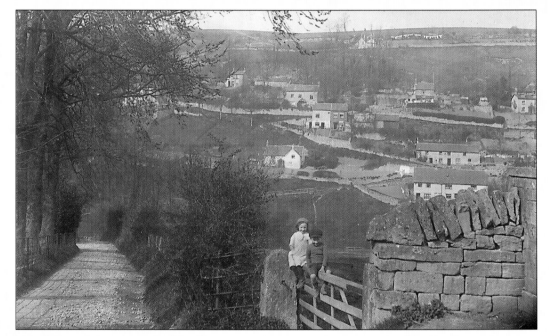

E.P. Conway stood in the road leading down from Shortwood graveyard to take this pleasing picture of Newmarket, which is reached by following the lane and crossing the stream below. The gate upon which the carefully posed children are perched has been replaced by a metal one, the trees have gone and more houses now appear on the hillside beyond. Otherwise the scene is easily recognisable. Part way down the lane there once stood a pub with the curious name, The Rotten Rail.

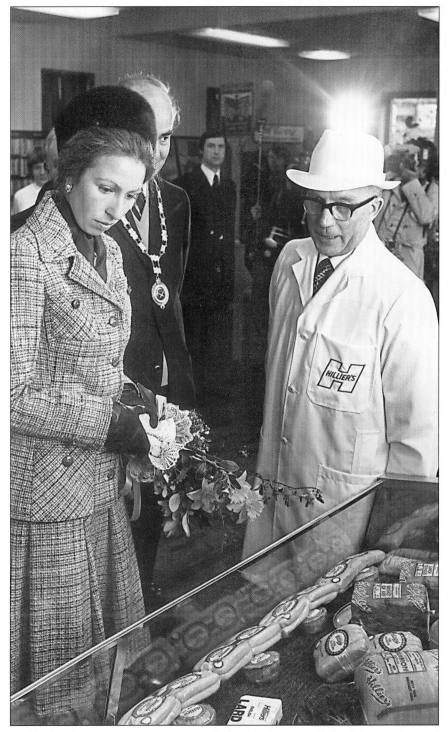

At Newmarket, many early cottages have been carefully restored.

Three royal visits to the Nailsworth area feature in this book, the first of which, in April 1978, involves Princess Anne. The reason for including a photograph of Her Royal Highness at this juncture is that she is inspecting a range of products, from Hillier's Newmarket factory, on display in the library. Her visit to the town was the first local excursion the Princess had made since moving into Gatcombe Park and her duties included planting two maple trees in Old Market to commemorate the Queen's Silver Jubilee. During her time in the town the Nailsworth Band played *Gatcombe Park*, a piece composed for the occasion by the band's musical director, James Portbury. Maypole dancing and a judo display preceded Princess Anne's visit to the library where, incidentally, she inspected Nailsworth's first local history exhibition, arranged by Betty Mills. Before leaving the town Her Royal Highness accepted a Hillier's gammon joint. An amusing event occurred during the visit when a three-year-old admirer presented the Princess with a single red carnation, apologising for its condition with the words, 'I'm sorry it's bent!'

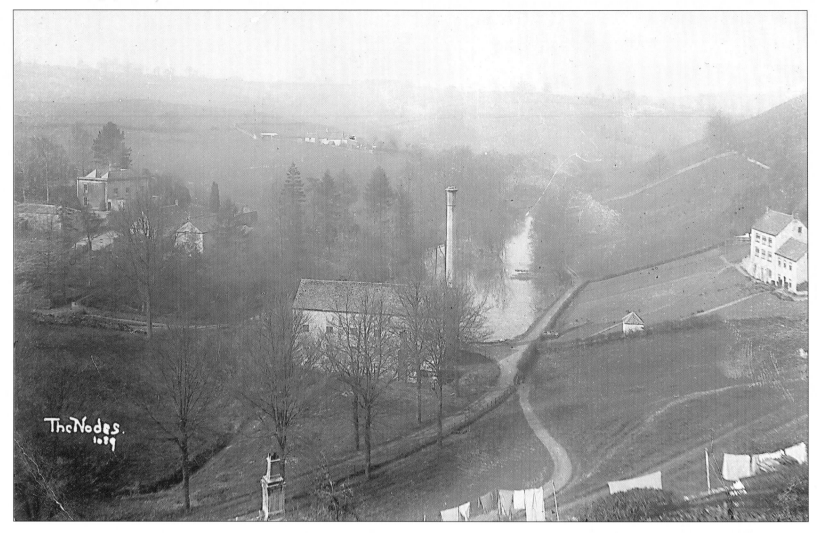

Nodes Mill, also known as Upper Mill because of its position furthest up the Newmarket valley, was no longer in use by 1882. It was later demolished and its stone re-used in Nos 1 and 2 Field View Cottages in the Bath Road. Seen in the upper left section of this Edwardian picture is The Nodes, built around a core of earlier buildings for Peter, son of Isaac Hillier, founder of the well-known bacon-curing business. Isaac lived from 1797 to 1886. To the right of the millpond can be seen a small pumping house. Its machinery remains intact today. It served to supply water to Hillier's factory further up the slope in Newmarket. The field on the near side of the pumping house was rented by my great-uncle, Cecil Weight – mentioned earlier – as pasture for his animals.

Top:

Hillier's delivery vehicles were a familiar sight a generation or so ago, not just around Nailsworth, but in many parts of the country. Progress is of course inevitable, but it does, somehow, seem a shame when a trade name familiar for almost two centuries disappears, as Hillier's has – especially when it contributed to putting Nailsworth's name on the national map.

Bottom left:

A century or so ago Hillier's produced a number of amusing postcards, intended for issuing to clients who needed reminding that orders were ready for despatch, or to request information or custom. The same stuffed pig appears on all of them. The caption on one such card reads, 'A Lucky Pig' – though one is tempted to ask in what sense any pig in a bacon factory could be considered fortunate!

Bottom right:

The debris resulting from the demolition of Hillier's factory presents an unattractive scene, but plans are afoot to redevelop the site.

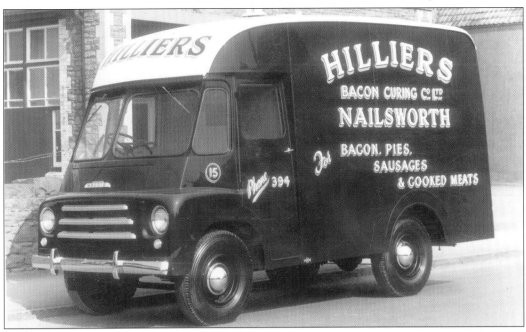

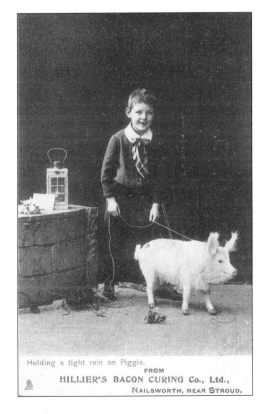

Holding a tight rein on Piggie.
FROM
HILLIER'S BACON CURING Co., Ltd.,
NAILSWORTH, NEAR STROUD.

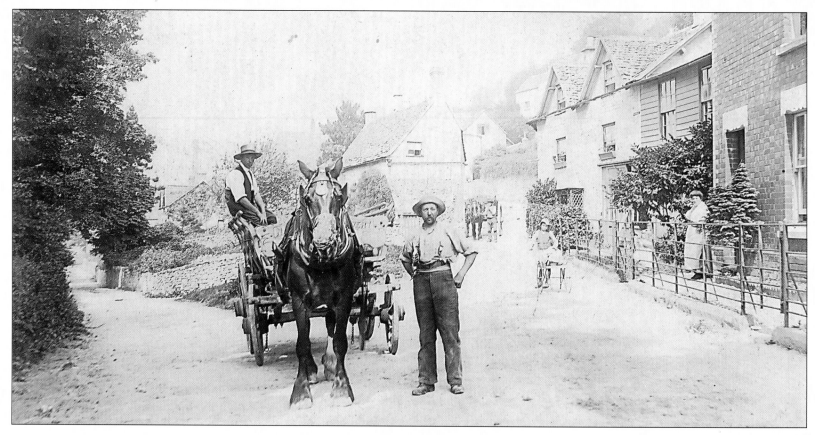

In this appealing, but rather faded, picture a Nailsworth Brewery cart stands near the George Inn at Newmarket, no doubt delivering to various local pubs and beer houses. The draymen in the photograph, which dates from around the time of the First World War, obviously enjoyed being photographed. At the double-gabled house to the right, carts were repaired and there was a laundry at the rear of the premises.

The George Inn forms part of an attractive row of early stone-built cottages.

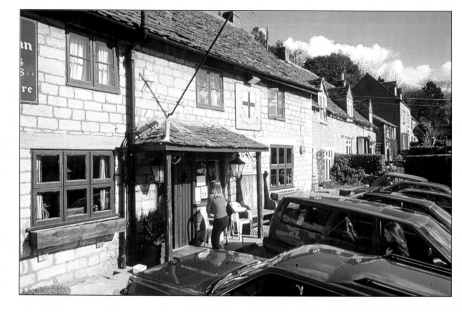

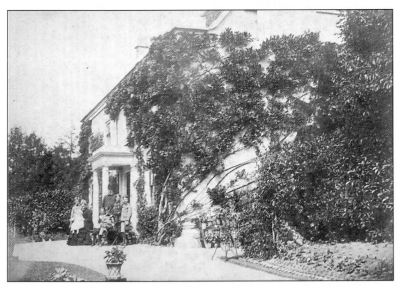

Newmarket House has been the family home of the Newmans from 1877 almost through to the present day. It started as a row of cottages, before being re-fronted and extended. The photograph shows it as it was around 1890.

No history of Nailsworth, even a light, pictorial one such as this, would be complete without mentioning a little more about the Newman family. Descended from Revd Thomas Fox Newman of Shortwood Chapel, who died in 1868, the Newmans had interests in the wool trade and were active in most aspects of local public affairs. At Newmarket House – which should not be confused with Newmarket Court, demolished around forty years ago to make space for Hillier's factory extension – Thomas Mayow Newman lived a century ago with his large family, three generations of whom are shown here.

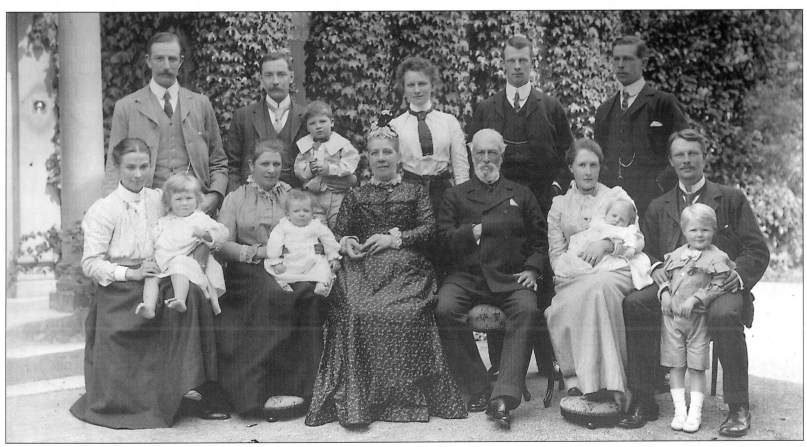

Seen from The Roller, Chestnut Hill descends gently to Cossack Square.

The appearance of the junction of Northfields and Nympsfield Roads was changed dramatically by the demolition in 1972 of Forest Green Congregational Chapel, the last survivor of three buildings belonging to the same denomination in the hamlet. Its Sunday School building, however, survives, serving as a base for – among other activities – a thriving table-tennis club. The organ from this plain, but fine, example of non-conformist architecture went to Prinknash Abbey at Cranham.

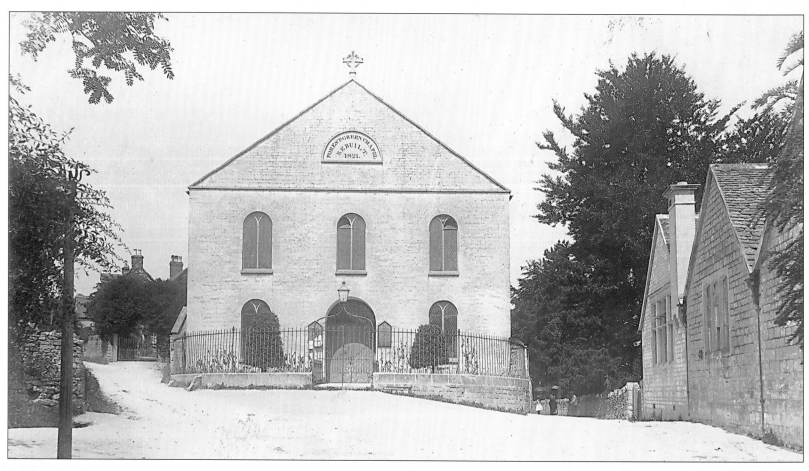

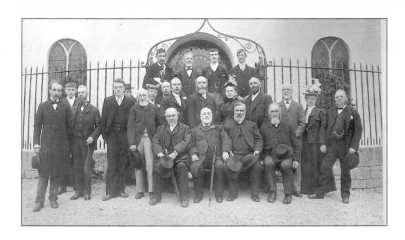

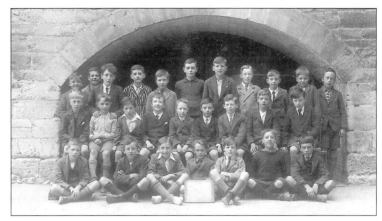

A Gilbertian phrase 'dignified and stately' seems appropriate to describe this assemblage of clergy and local worthies, gathered in front of Forest Green Chapel. From their dress the photograph would appear to be Edwardian.

On the lower side of Northfields Road, and close to the chapel, is the former Boys' School, which is now, with the removal of its pupils to roomier accommodation at Highwood, converted to private housing. Many pictures similar to the one shown here exist of pupil groups, framed in a distinctive arch on the lower side of the main building.

Images of landscapes and buildings of a century ago are relatively common – studio portraits even more so. Those showing people at work are rarer. Here, at Hayes Road, with The Acacias in the background, a horse-ploughing team prepares to cut a new furrow. The picture is one of a group of photographs by E.P. Conway which date from around 1910. The photographer captioned it, 'Smallholders ploughing and sowing a crop of green fodder'.

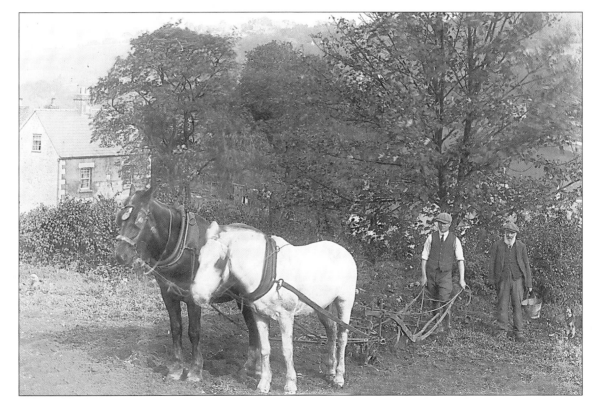

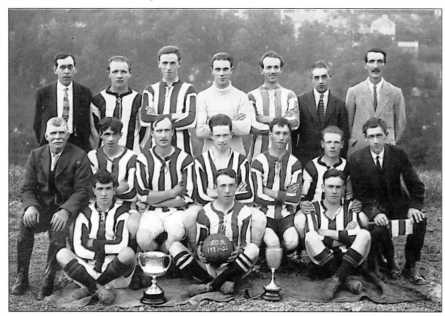

Forest Green Rovers have become successful not only locally but also, on occasions, on a National scale. The photograph included here shows the team's second XI, winners of the North Gloucester League Division II and Stroud and District League Division III Challenge Cups for the season 1921/22. The modern picture shows Forest Green Rovers – in the black and white strip – in action against Hereford United on a fine early spring day in 2000. (Just for the record, the visitors won 1-0.)

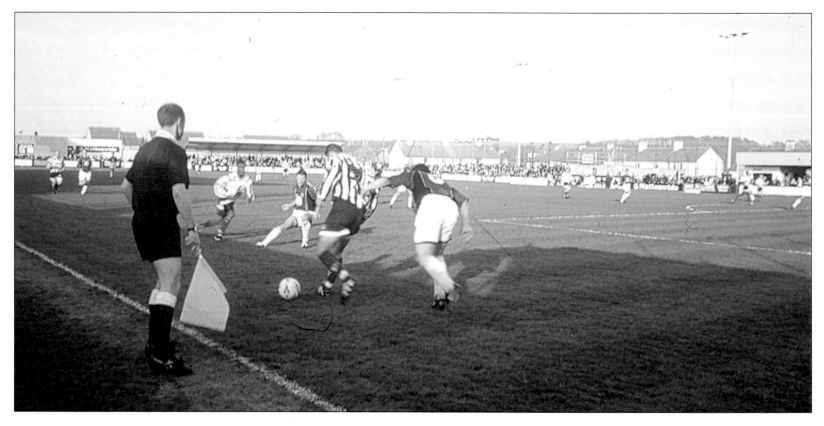

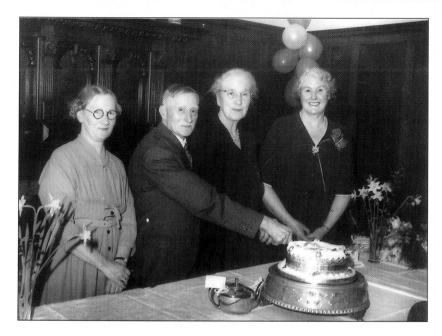

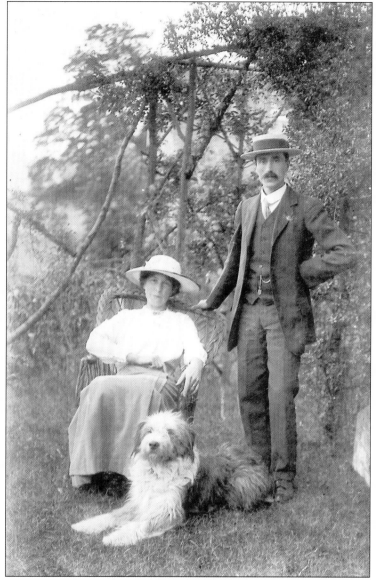

Rosanna Beard, born in 1881, was my grandfather's youngest sister. She grew up at the family home in Northfields Road and, shortly after her marriage to Cecil Weight, moved a few yards up the hillside into The Haven, one of two similarly named houses in Forest Green, where they spent almost sixty years together until Cecil's death in 1966. The decline in his health, I am told, was triggered when, already over eighty years old, he fell from an apple tree in his garden.

Because generations in my family were well-spaced and my last surviving grandparent died when I was only seven, it was from Rosanna, or Auntie Rose as we called her, that I learned what little I know of my nineteenth century Nailsworth ancestors. She claimed she could remember her own grandmother, born in 1808, and she told me the story of the fire in the 1850s in which my great-great-great-grandmother burned to death – of which more later.

But what, in retrospect, impresses me most about Auntie Rose and her husband, Cecil, (she pronounced it with a long 'e') was their devotion to each other and their wholesome, country lifestyle. Employed for most of his working years in the bacon curing industry, Cecil's job was also his hobby. The garden at 'The Haven' contained enclosures for pigs and other animals and, especially on our traditional Boxing Day visits, Cecil, in his broad, rich, Cotswold accent, would encourage us to pile our plates high with huge slices of his own home-cured ham, while Rose embellished the feast with salad, home-grown potatoes and over-sized pickled onions.

They were an interesting couple, practical and plain speaking, of a simple Gloucestershire type which, although found less frequently today, still exists in country areas. Childless, Rose's *raison d'etre* disappeared with Cecil's demise, and she lived on only a couple more years.

The photograph on the right is Edwardian. In it they relax in their garden with a favourite companion, Carlo. The picture on the left shows their Golden Wedding celebrations at the George Hotel in Nailsworth where, incidentally, Rose's father, Stephen Beard (1839-1825) had worked for many years as a gardener.

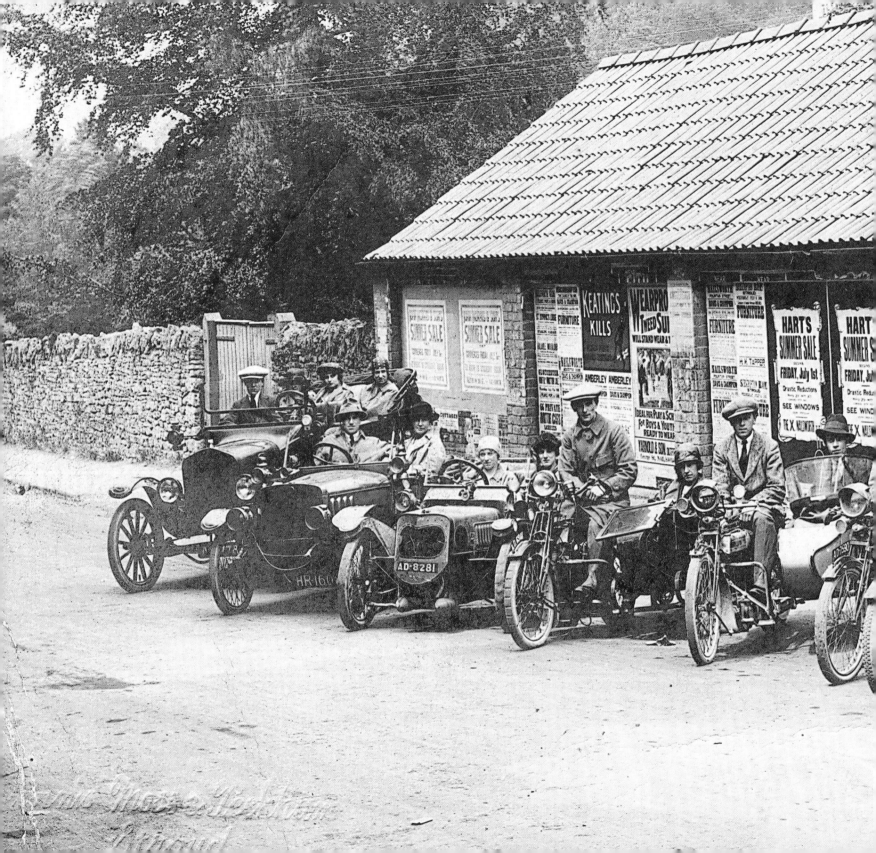

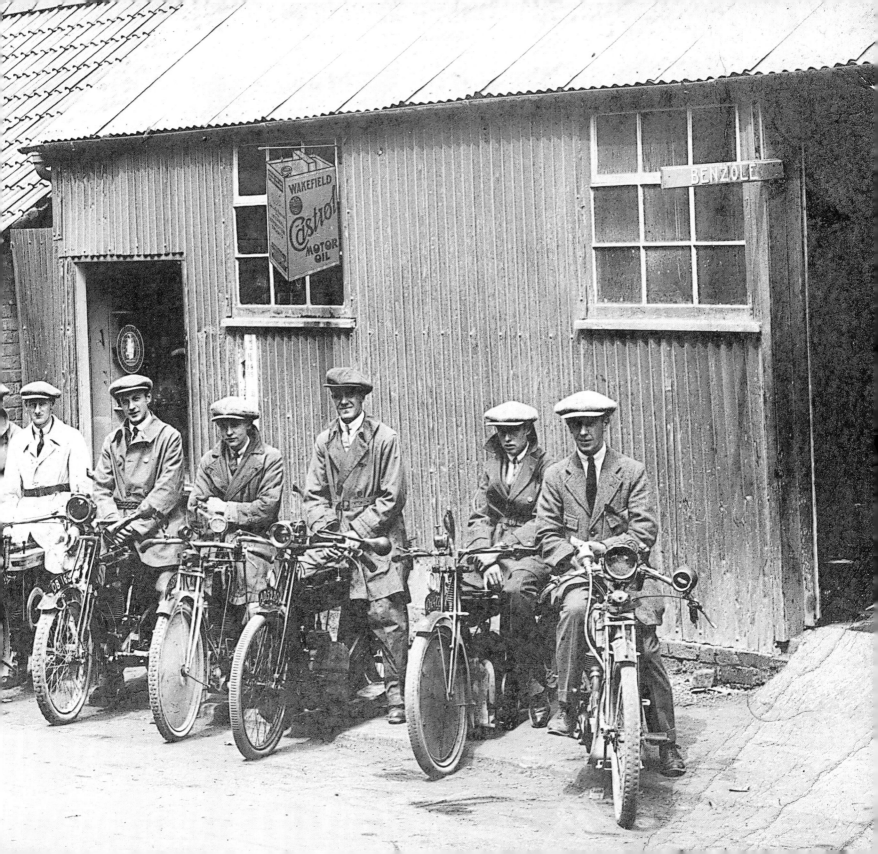

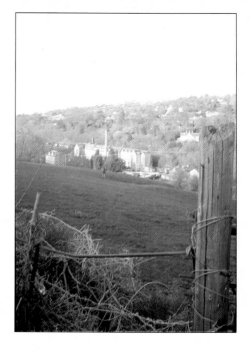

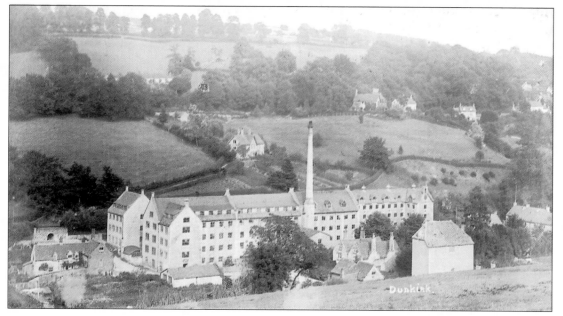

Dunkirk Mill is, by any standards, impressive. It is reputed to date back, as a fulling mill, to the early seventeenth century. Rebuilt in 1798 by John Cooper and acquired by the Playne family in 1815, steam had been installed in it by the 1830s. From 1891 it was occupied by W. Walker and Sons of Nottingham, who ran both hosiery and stick-making businesses from the premises. By the 1970s it was largely unoccupied and has recently been converted into flats.

Previous page:

Down the hillside from Forest Green, on the Bath Road between Egypt and Dunkirk Mills, was Ralph Dee's garage. In this 1920s view, a group of motorcyclists and early car enthusiasts assemble before setting out on a rally, hill-climb, or perhaps just a pleasant afternoon tour to a location such as Cheddar Caves.

Top left:

Cecil Weight loved his smallholding and would approve of The Haven's current neat lawns and flower borders. He would also be pleased that what was his home for so many years is still occupied by members of the family, the Robinsons.

Top right:

Dunkirk Mill dominates the valley bottom. It is seen at its best from Northfields Road.

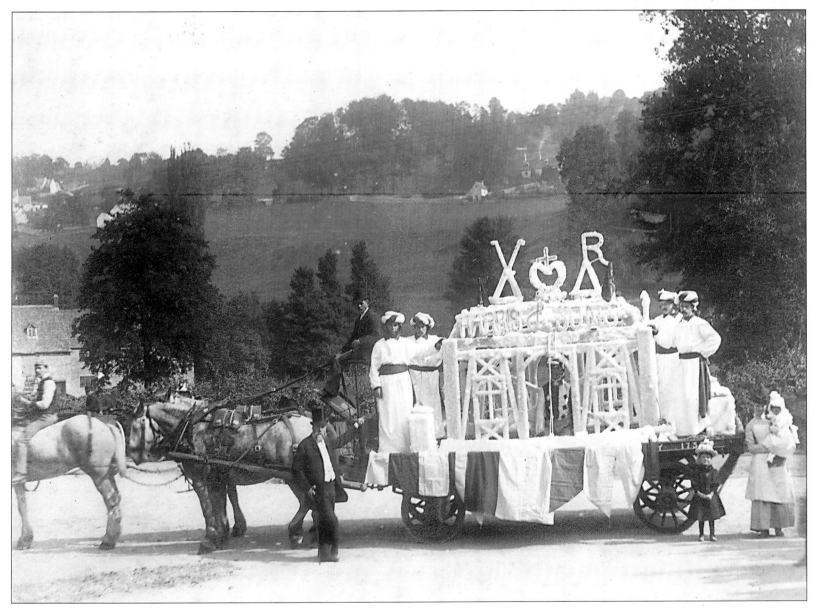

In September 1890 J. Harris and Son, whose principal product was borax candles, entered this float for the Stroud Hospital Show carnival. (Borax, I am told, can also be used in a range of other processes, including the manufacture of glass and ceramics.)

In the *Stroud News* the report of the Show stated that Harris's float was, 'without doubt the prettiest of all the cars', that it had taken a long time to assemble and contained candles worth £100 which weighed between three and four tons!

Crystal Fountain Mill, where Harris's factory was based, was located up the valley behind the Crown at Inchbrook, where this photograph was taken. It has now entirely disappeared.

The picture of the float is, in my view, one of the most attractive early images to survive from the Nailsworth area.

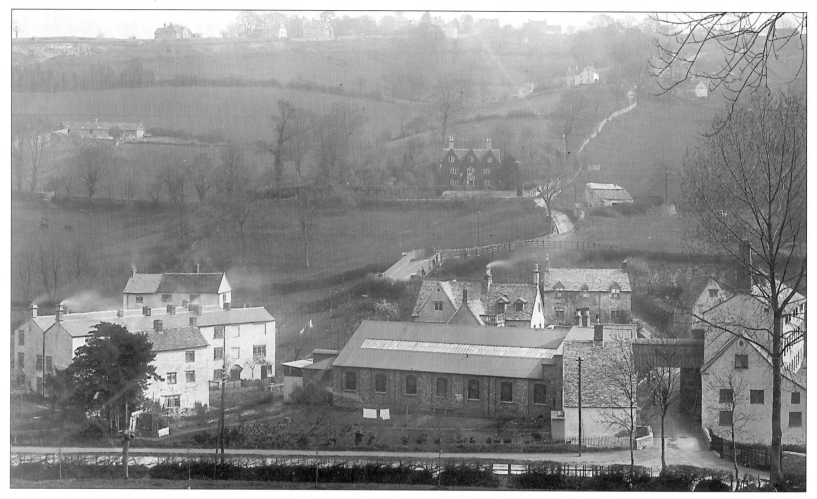

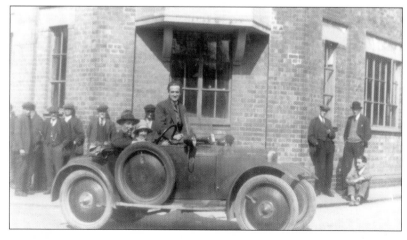

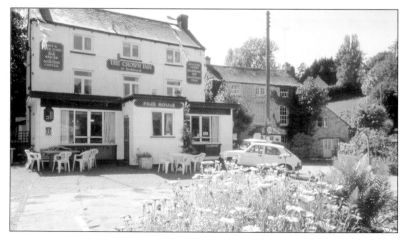

Opposite page, top:

Taken from elevated ground near Woodchester Priory Church, this view is difficult to locate. The reason, of course, is that the buildings in the central area of the picture, taken around 1910, were replaced by the distinctive factory block erected by Newman Hender and Co. Ltd a few years later. On the left is Merrett's Mill, with Dyehouse Mill vanishing off to the right.

Bottom left:

Not long after the completion of the new factory building, with its zigzag skyline silhouette, Mr Frederick Payne, an employee, was photographed in front of it in his 8 horse-power Rover. This model was made up to the mid-1920s, which is roughly when we may assume the picture to have been taken.

Bottom right:

The lane leading to the site of Crystal Fountain Mill runs past the side of The Crown.

This page, bottom left:

Although much post-Victorian development has taken place along Theescombe Lane, this view from Giddyknapp shows little hint of it.

Bottom right:

Between the graveyard crosses of Woodchester Priory Church the buildings of the former Newman Hender and Co.'s factory can be seen. To the left of the picture are the gables of Giddyknapp House (pictured top right), which has a fine shell porch. Theescombe is away to the right.

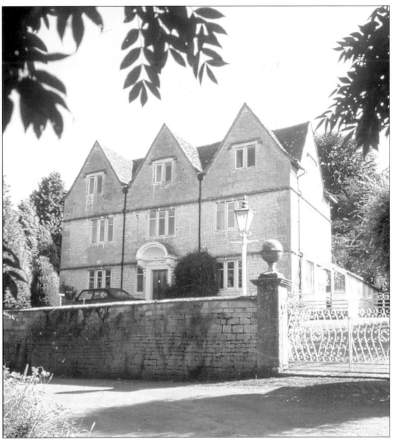

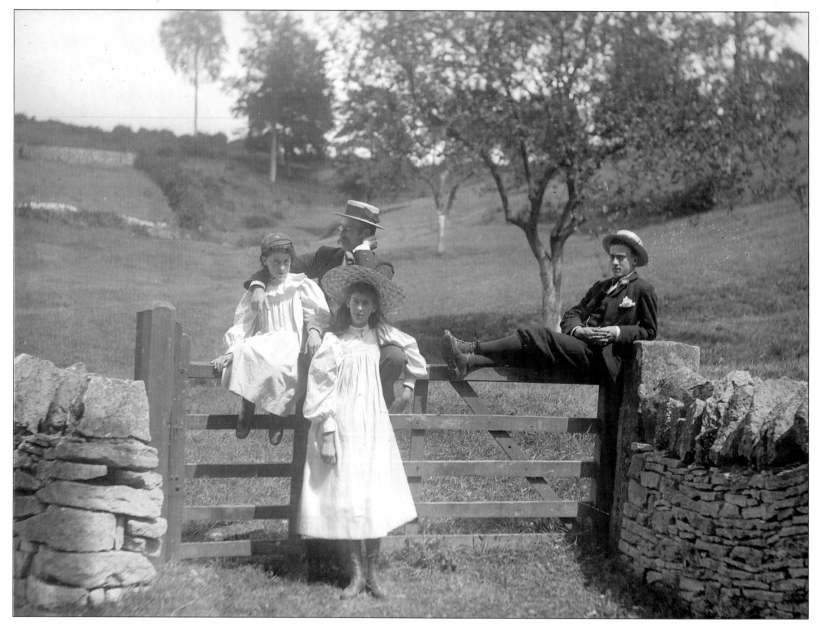

It would be hard to find a more charming study of Edwardian children than this photograph from the collection of the late Roy Gardner of Amberley. It was taken in Theescombe Lane and is of members of his family.

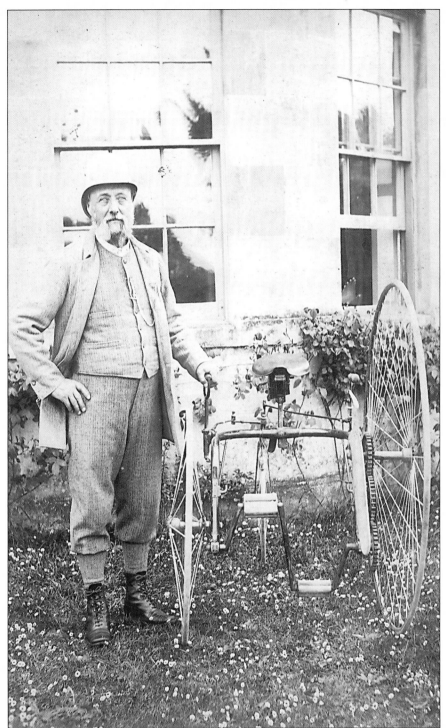

Across the valley from Theescombe, Woodchester Priory Church, now bereft of its domestic buildings, guards the approach to the fine series of picturesque lakes which lead up to Woodchester Mansion, Benjamin Bucknell's partially completed mid-Victorian masterpiece.

Revd Augustus Turner lived for many years at Dunkirk Manor. He was born around 1820 in Dorset. A number of good photographs taken in his later years have survived, passed down through his descendants, who were in business in Nailsworth. Augustus was a man of varied talents. He was, for instance, a good amateur artist and painted the picture of Minchinhampton Windmill now in the collection of Stroud's Museum in the Park. Revd Turner's tricycle, though quaint to modern eyes, was of a type common in Victorian days.

What is this life if, full of care, we have no time to … pause in Watledge outside the low-browed cottage where the poet W.H. Davies spent the last years of his life.

In the front room of her cottage at Watledge, Lily Woodward, a member of Nailsworth's long-established family of builders, carpenters and undertakers, ran a small private school. My mother was a pupil there for three or four years from around 1906. The photograph, by Nailsworth photographer P.L. Smith, can be dated fairly precisely to just after 1900, since Lily's nephews are amongst her pupils. Second from the left in the back row is George Woodward, born in 1890; front right is Leslie, born in 1898. Lily died in 1927.

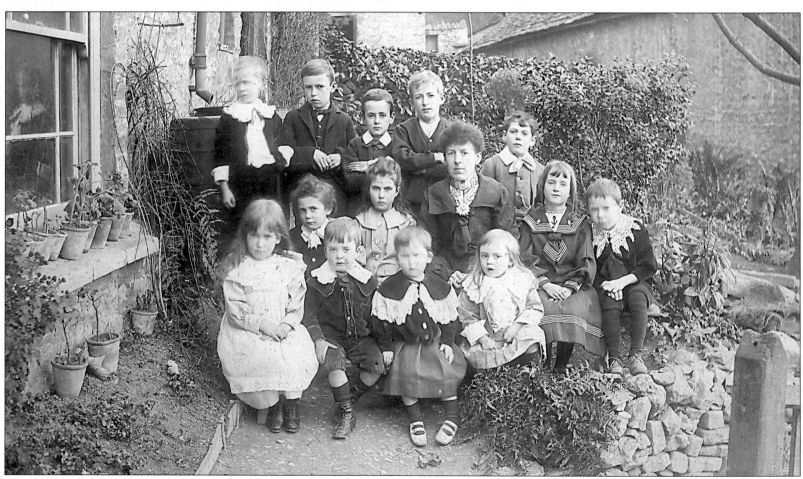

M otor vehicles, sheds, garages and the odd television aerial apart, the row of cottages in which Miss Woodward ran her school a century or so ago has changed little.

I n early times roads tended not to be built on exposed hilltops or in the marshy valley bottoms. Watledge, seen here from Forest Green, demonstrates how, locally, lanes often follow the sides of hills, with cottages easily accessible from them by cart or packhorse.

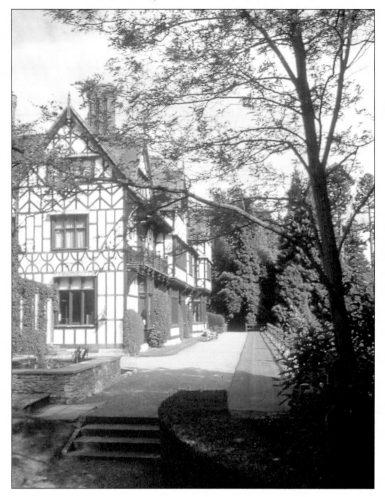

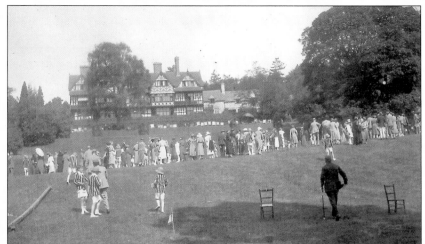

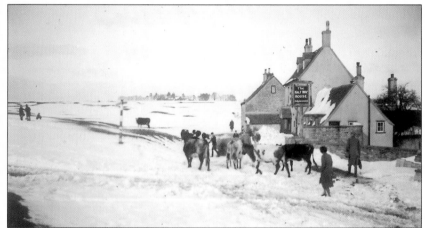

Above:

Minchinhampton Common is reached via Shears Pitch, a wood, a lane or two and a short tunnel. At its edge stands The Highlands, an imposing structure in extensive grounds, built by J.G. Frith in 1873 in mock Tudor style. In 1918 the estate was purchased by A.H. Richardson for use as a school. He renamed it Beaudesert Park, after the Warwickshire village near Henley-in-Arden from which his school had moved.

A traditional Prep. School, Beaudesert Park became co-educational some years ago and in 1987 my wife was appointed as Head of its new Pre-Prep. Department. I joined her on the staff a couple of terms later.

The school, set among mature trees and extensive lawns, enjoys fine views over the town towards Horsley.

Top right:

An annual sports day, during the inter-war years, is shown in this amateur photograph. It is amusing since it was developed back to front: the stone-built portion shown on the right of the picture is actually on the opposite end!

Bottom right:

If it snows anywhere, it snows on Minchinhampton Common! Stories are told of snowdrifts, during the exceptionally severe winters of 1947 and 1963, level with the height of the roofs of single-decker buses. A more modest sprinkling is shown here, but the photograph is interesting none the less: the fall must be either very early or exceptionally late, since cattle are, of course, normally absent from the common in winter. The Half Way House refers to its location between Nailsworth and Minchinhampton. I have not come across this name for it before 1939, when it was a beerhouse known as Fives Court.

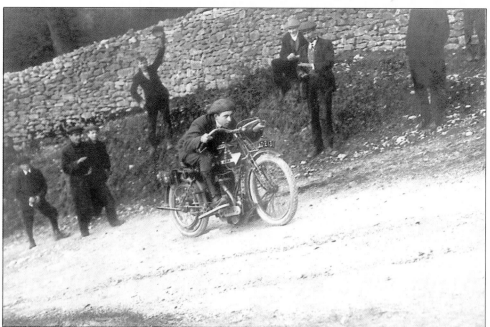

While the 'W' zigzags gently up from Nailsworth to Minchinhampton Common, 'The Ladder' takes a much more direct and steeper route, providing an ideal gradient for car and motor cycle trials. The young man the onlookers are encouraging is astride a locally registered 1912 BSA machine, though I half-suspect the vehicle may actually be stationary: is that a box for supporting the rider's foot visible on the ground at the far side of the motor cycle?

When I was a child, living in the next valley, a favourite afternoon's excursion – which I invariably shared with Doris Royle, the adoptive aunt who lived with my parents – involved catching a green single-decker Minchinhampton bus in front of the Phoenix Inn at Thrupp. After alighting at Tom Long's Post, a short walk through harebells, milkwort, wild rockroses and yellow vetch would bring us to the shade of a spreading beech tree at the top of 'The Ladder' on Nailsworth Hill. Here we would enjoy a picnic before beginning the steep descent to the town. Once in Nailsworth our destination was the little shop on Market Street where my mother's aunt, Eva Allway, helped to run a small business selling boot polish and shoelaces. This enterprise was, in fact, all that remained of the shoemaking concern once operated by her sister Lily's long-dead husband, Sam Dodge. After I had been taken through to the small sitting-room behind the shop to meet Lily – who was by now totally blind and deaf and recognized me only when her sister took her hands and passed them over my face and head – I was then allowed the privilege of serving any of the few faithful customers who dropped in to patronize the shop. For me this was the highlight of my visit and also, coincidentally, a means of brushing up my mental arithmetic!

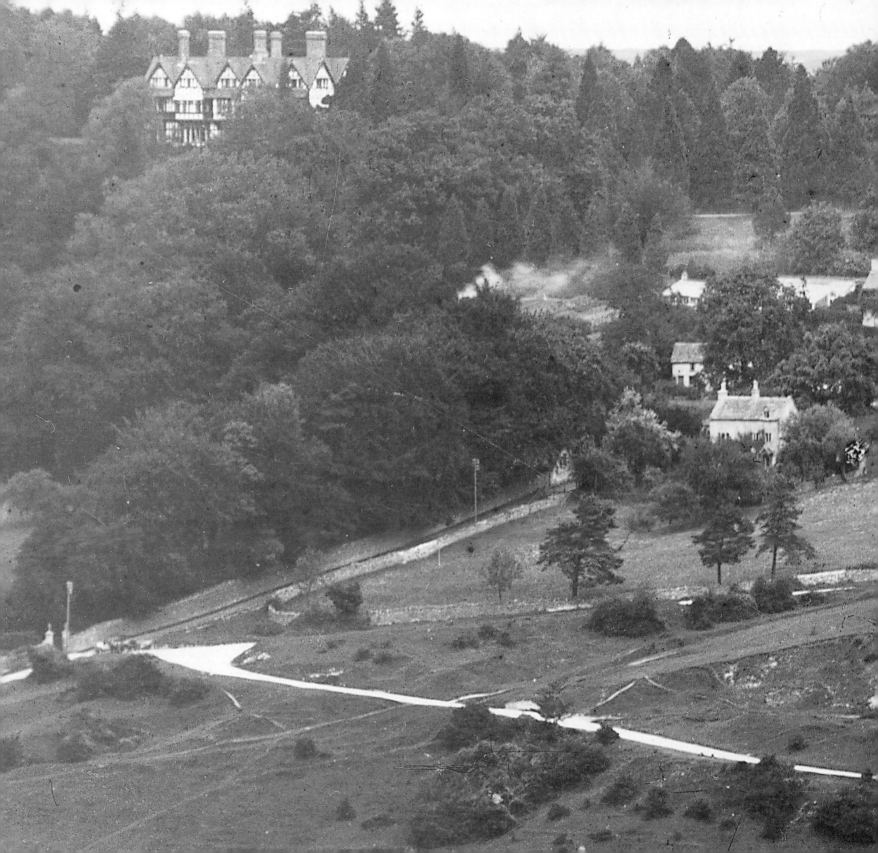

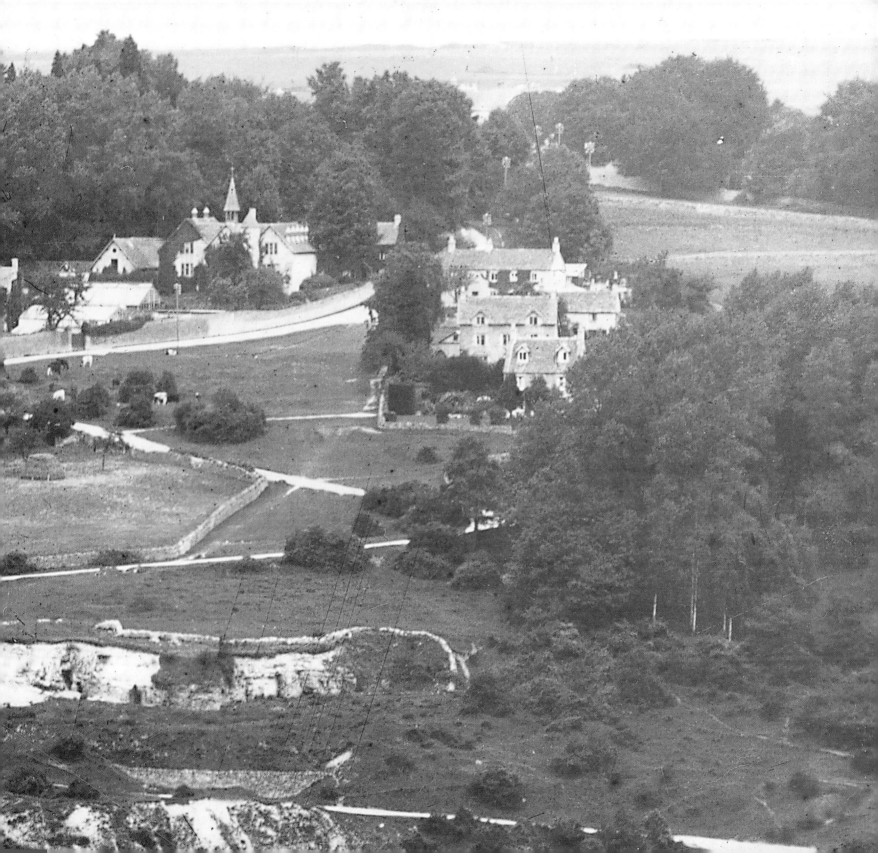

Previous page:

Almost the entire 'W' can be seen quite clearly on this late Edwardian postcard. Note the piles of quarry spill, masked today by an overlay of grass and trees. In the distance, to the left, The Highlands nestles amongst trees which include an avenue of Wellingtonias. (When a diseased specimen was felled recently, a tree ring count proved that these fine examples were planted in 1873, the year the house was erected.) The little turret on the stable block is also visible; the buildings around and to the left of it were glasshouses and servants' accommodation – now mostly used as staff quarters for the school.

The more elevated areas of Nailsworth are visible from the hill slope near Scar Hill.

Longford's Mill, below, formerly provided employment for hundreds of local clothworkers who travelled in from a wide radius around. Today – empty, deserted and vandalized – its buildings remain an impressive reminder of the decline of an industry once so central to the prosperity of this part of Gloucestershire.

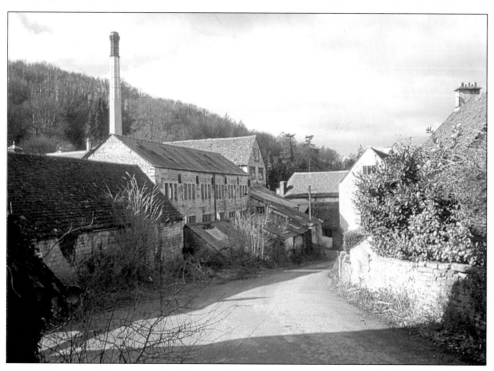

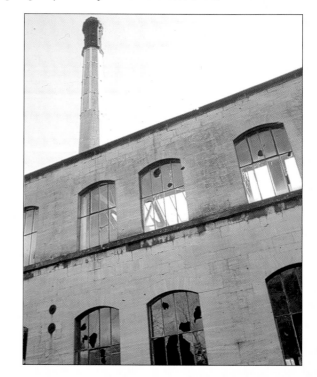

There are a few pictures in this collection which have appeared in print before but, for one reason or another, are too good to omit: this is one. E.P. Conway's photograph of Longford's Lake is a fine image in its own right, with its lake, mill and mill owner's house. What, however, makes it amusing is that – presumably in order to create atmosphere – Conway thought it necessary to paint in a large swan which, if to scale, would be around ten feet tall!

Longford's Lake was created in 1806 and was, at that period, fifteen acres in extent: silting has since reduced its area. It is privately owned and adjoins, in part, the Gatcombe Estate of The Princess Royal. Insofar as it is possible to view it from a place of public access, it is best seen from an elevated bend on the road from Nailsworth to Avening.

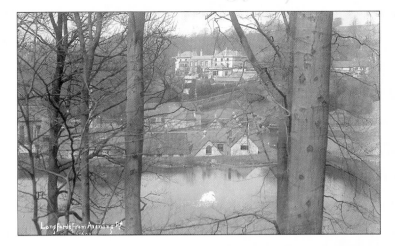

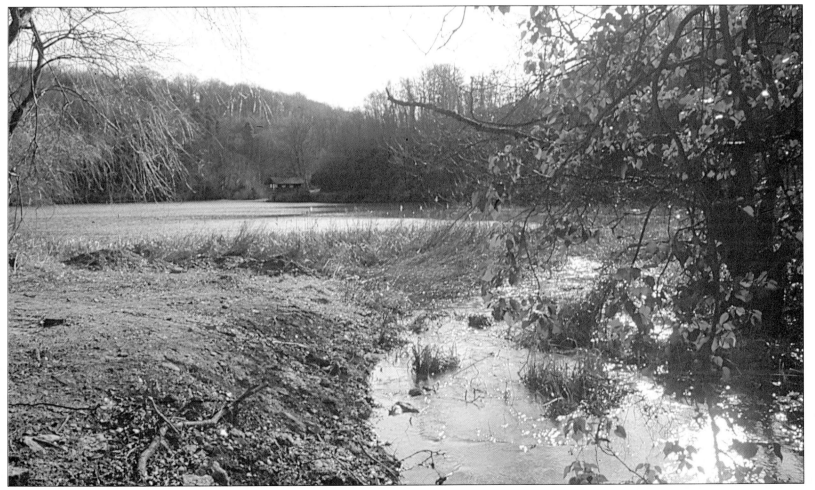

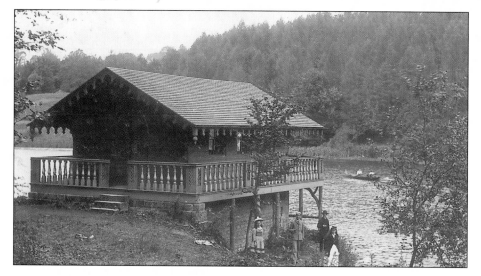

Bottom left:

Below Ironmills Common The Weighbridge Inn nestles in the valley at the point where the road from Minchinhampton joins that from Nailsworth to Avening.

Bottom right:

For sheer quality of focus, exposure and subject matter this superb picture of Fletcher's fish cart at Iron Mills must place it as a leading contender for the title of best Nailsworth photograph taken before the First World War. In his shop, which was the building in Fountain Street now occupied by William's Kitchen, Harold Fletcher was assisted by his two daughters. At a slightly later period, fried fish and chips were also sold from the premises.

At one time Longford's Lake had no less than three boathouses. The gothic-arched, stone-built one, much extended, has become a beautifully situated lakeside house. The Swiss chalet style boathouse has also survived remarkably intact. The group, seen here standing near the latter, are probably members of the Playne family, who owned the mill around 1900, when the picture was taken.

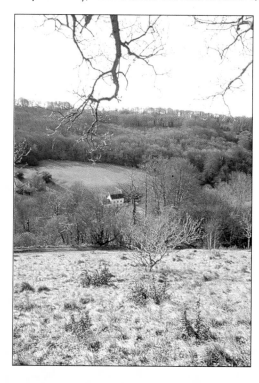

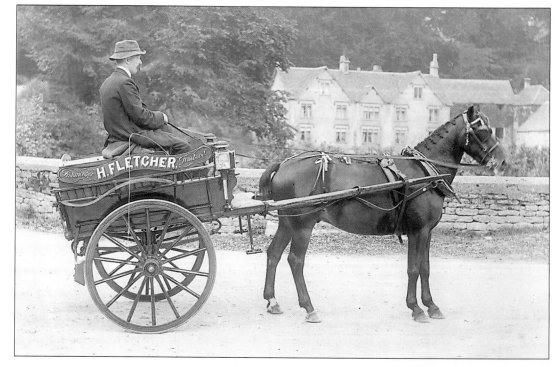

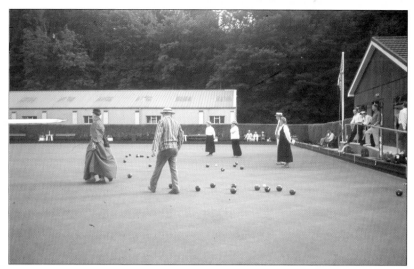

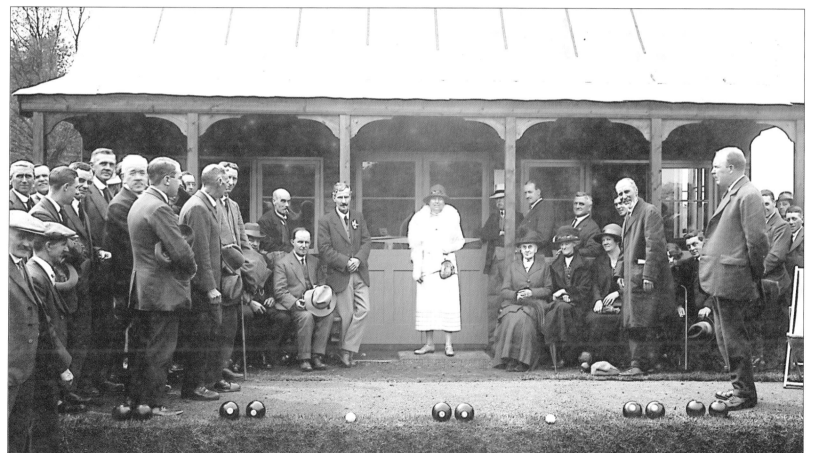

Previous page, top left:

Off the road that leads back into Nailsworth, Tubby's restaurant, a part of Waterside Garden Centre, offers welcome refreshment.

Top right:

In the spring of 2000 Nailsworth Mills Bowling Club celebrated the centenary of its foundation with a day of matches played in period costume. This picture is from the author's own collection.

Bottom:

At one time bowls was played on a green behind The George Hotel. However, the club fell on hard times and, in 1924, Mr E.A. Chamberlain suggested that, in exchange for his paying off its debts, it should move to a new green at the rear of his factory in Avening Road. A pavilion, only recently replaced, was built and the first wood was bowled at the opening ceremony on 31 May 1924. In the photograph Mrs Chamberlain is seen in the centre of the picture, with her husband standing far right.

This page:

To cover the period, in the 1890s, between the demolition of the Pepperpot Church and the completion of its replacement, a temporary tin church was put up in the grounds of the vicarage off Avening Road. Its exact location can be ascertained since, in this photograph by Joseph Smith of Stroud, the vicarage itself is clearly visible in the background. Ronald Woodward recalls how his grandfather's Watledge building firm was assigned the job of collecting sections of the church from Nailsworth station, transporting it to the vicarage on a handcart and erecting it. Rates paid for this were as follows: 6d an hour each to George Woodward and his two carpenters, 4d to two labourers and 3d to two boys. There was also a beer allowance of 18d a day for the group.

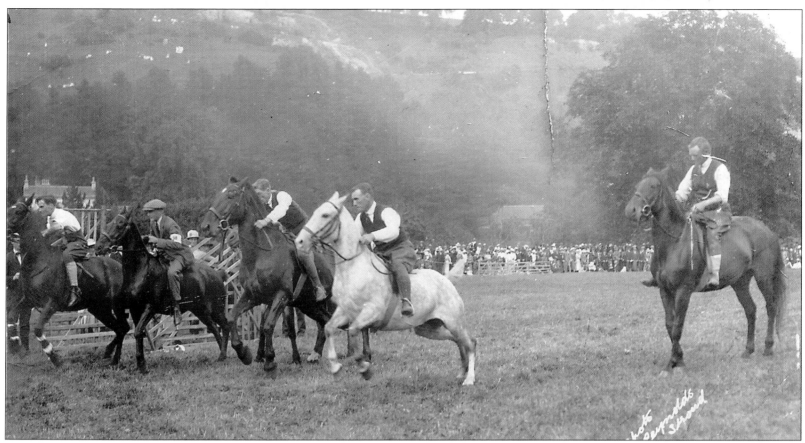

Nailsworth Horse Show, held at the Playing Fields near Park Road, was an important event in Nailsworth's leisure calendar in the early years of the twentieth century. Many photographs exist of the carnival processions that were an essential part of it, but pictures of the actual races are rare. Note that the riders are dressed in their ordinary clothes, rather than equestrian habit. A sizeable crowd looks on in the background.

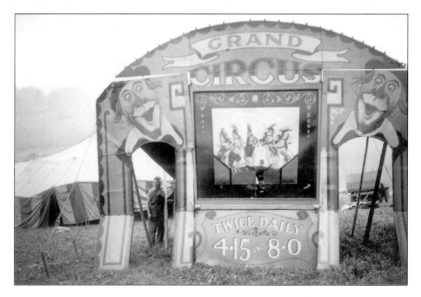

Lionel Bathe, of whom we shall learn more later, lived almost all his life in the same cottage in Brewery Lane. He was a keen photographer, taking both prints and movie film. He also made many interesting tape recordings and had a fascination for circuses, which often visited Nailsworth Playing Fields. This, according to Lionel's records, is the entrance to Bob Fossett's Circus, which performed in the town on 3 May 1940, when Lionel was a young man of twenty. In exchange for displaying posters in their shop windows, it was apparently the custom for local business people to receive free tickets for the show.

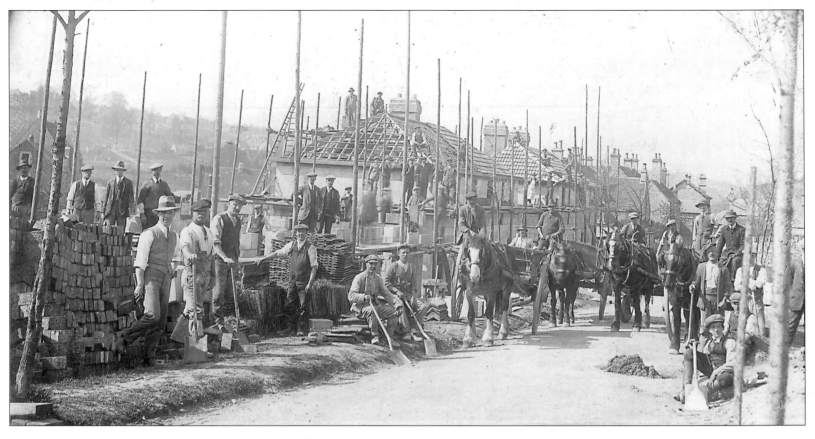

Park Road was developed in 1922 and E.P. Conway took several detailed photographs of building work in progress. The blocks from which the houses were built are of interest: stone was brought from Rowden Quarry and crushed on site, using a paraffin engine, then mixed with cement.

In Park Road, opposite the entrance to Gunbarrel Alley, are a number of attractive Victorian stone-built terraced cottages.

ouses in Church Street face the Acorn School and the drive which leads to The Mount. This was the home, in 1910, of Lemuel Price who ran a grocery business in Market Street and who was also Nailsworth's registrar of births and deaths.

At least two professional photographers are known to have worked in Nailsworth before 1900. The first was Alfred Jean de Rozier who, one may surmise, was of French extraction and also described himself as a Professor of Languages. Apart from a few studio portraits, almost nothing of his work appears to have survived. The second was Paul Smith whose first known work was in Stonehouse in the 1880s. Born in 1845, he was the brother of Stroud photographer Oliver Smith. Paul was active in Nailsworth from the 1890s until around 1902 and was responsible for a large number of cabinet-size pictures of street scenes, landscapes and events. His work is invariably of a high quality, as may be judged from this Victorian photograph of Shakespeare's *Twelfth Night*, staged at Bannut Tree House at the top of Tabram's Pitch. The girl reclining on the rug is Agnes Newman of Newmarket House. For many years she ran a popular Bible Class at Shortwood Chapel.

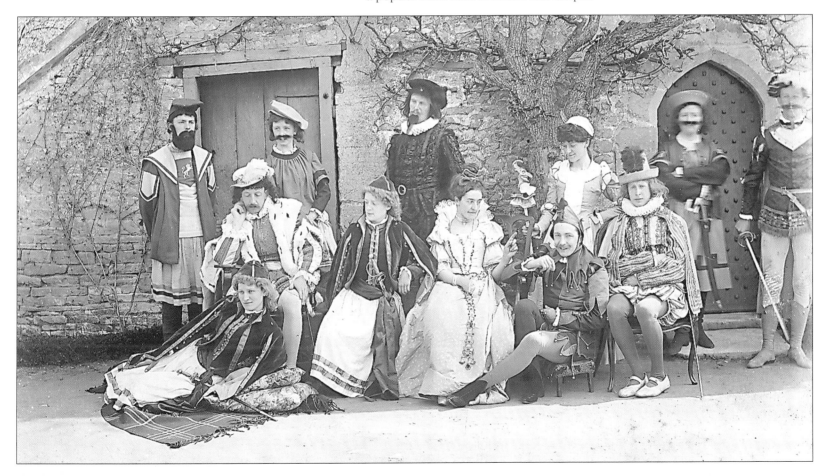

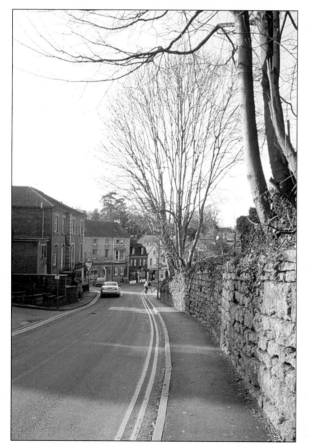

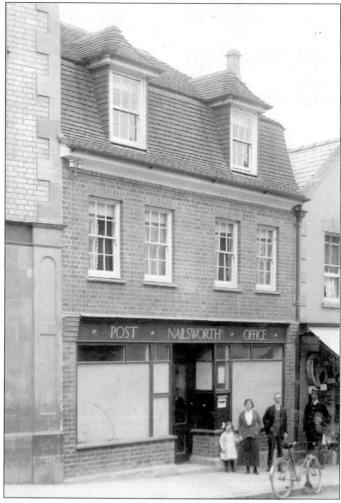

Above left:

Bannut Tree House is thought to date back, in part, to the sixteenth century. The chapel in its garden contains medieval elements.

Left:

Tabram's Pitch is named after a nineteenth-century Nailsworth auctioneer who lived at Bannut Tree House. His daughter Ellen ran yet another of Nailsworth's small private schools.

Right:

It is only very recently that Nailsworth's post office has moved to Old Market from its familiar location in Fountain Street. The postmaster at the time of this photograph, 1914, is believed to be Mr J.W. Soulsby, still remembered by older residents of the town. His son Tom took down the celebrated telegram from Dartmouth College which dismissed young George Archer-Shee, of The Lawn in Spring Hill, for stealing a postal order. This famous case formed the basis of Terence Rattigan's play, *The Winslow Boy*. To the right of the post office is Oliver Jeffery's cycle shop.

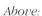

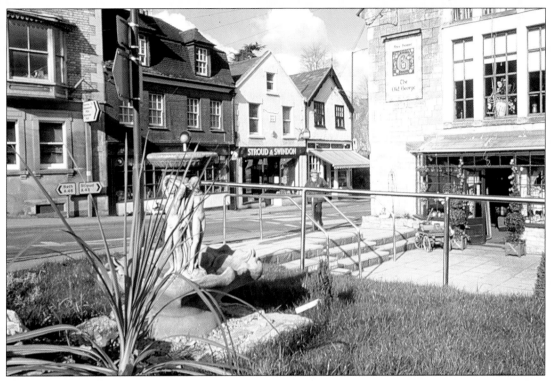

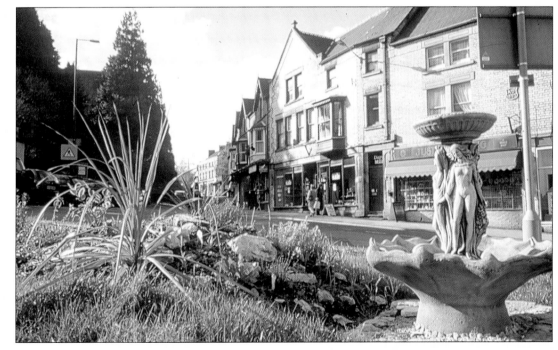

Above:

From George Street, the road to Minchinhampton begins its ascent towards the 'W'.

Top right:

The old masonic hall in Fountain Street has recently been restored and now houses a shop and, upstairs, the Old George pub.

Bottom right:

Looking in the opposite direction across the building's well-landscaped forecourt, the curve of Fountain Street is visible, with the silhouette of St George's Church on the left.

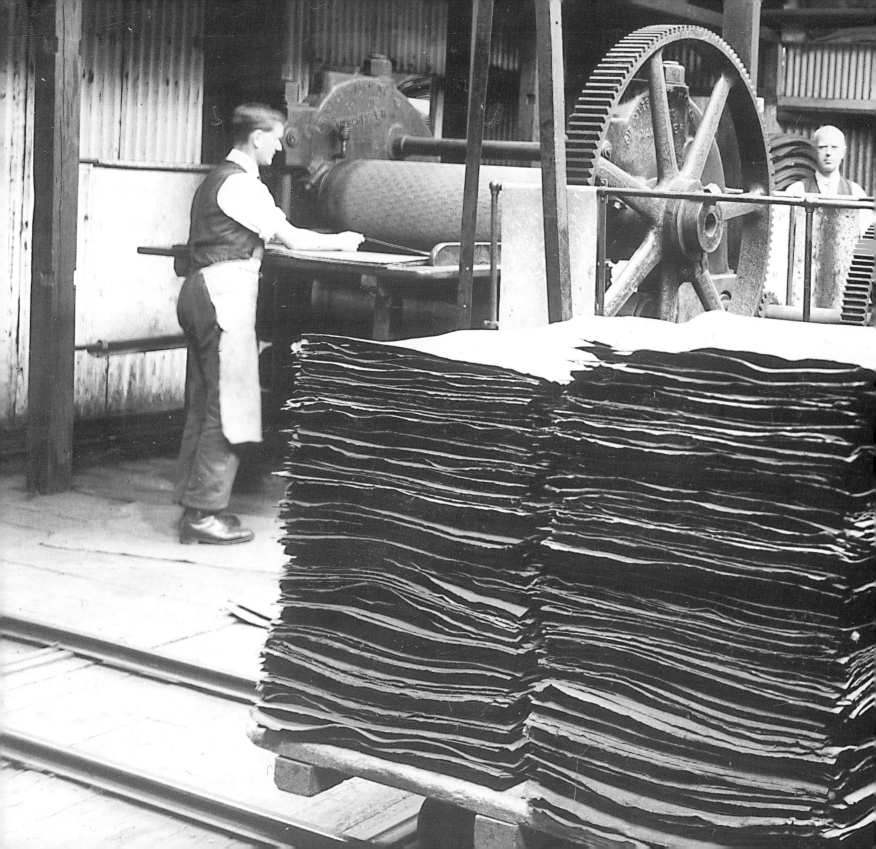

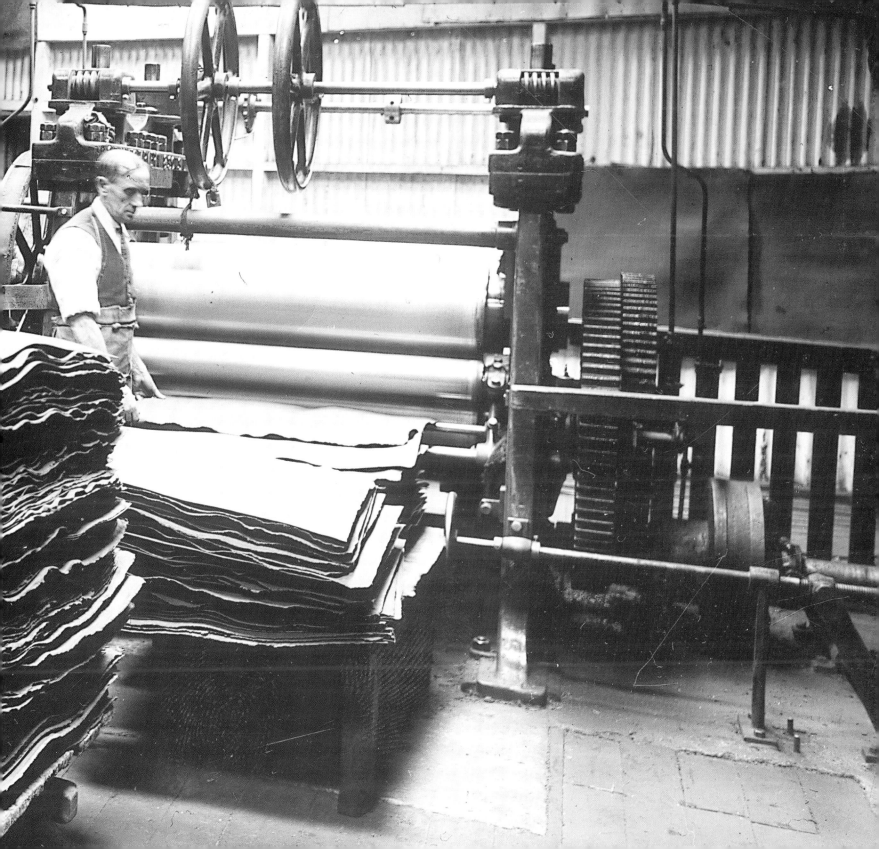

Previous page:

Employment in Nailsworth was, for decades, heavily dependent on Chamberlain's fibreboard factory. The firm was founded in 1879 and survived at least two major fires. In 1930 a photographer was commissioned to record the factory as it then was, both inside and externally. I have chosen from this collection the picture of the 'Calendering and Embossing Department'.

During my student days in the early '60s, when I was employed at Chamberlain's on vacation work, I recall not only the noise and rhythmic pounding of the board machines, but also the very distinctive aroma the process emitted. My great-uncle, Frederick Beard, also worked there many years earlier on maintenance and narrowly escaped serious injury when his clothes became entangled in a machine being operated without a safety guard. He was apparently lifted off the ground and left dangling in the air by his sleeve – a lucky escape!

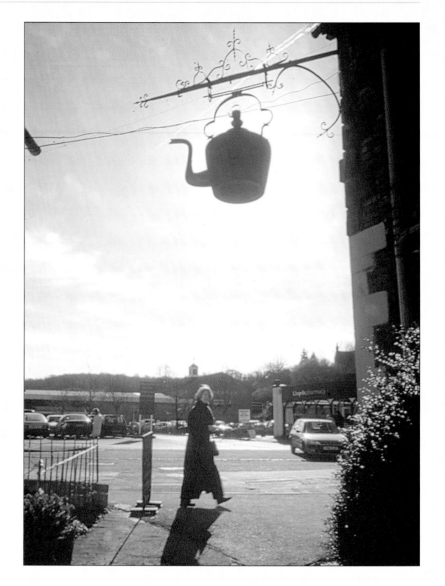

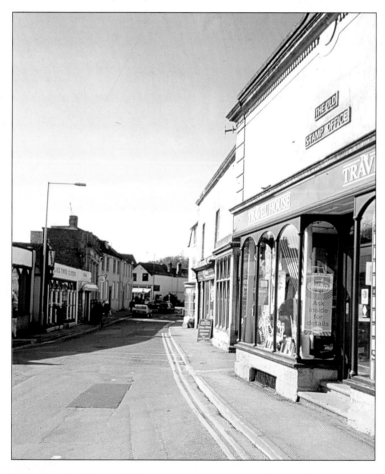

Above:

A few yards from the Old Stamp Office, fixed to the corner of what was Whiting's grocery store, is one of Nailsworth's most distinctive and well-loved landmarks, the Copper Kettle. It was placed there in 1887, as the inscription beneath it confirms, to celebrate Queen Victoria's Golden Jubilee. It is reputed to have come originally from a shop in Malmesbury.

Left:

The right side of George Street has the earlier and more interesting buildings. The Old Stamp Office is a particularly fine example.

In the 1890s Nailsworth experienced two major accidents, one in 1892, when a train passed at some speed through the station and crashed over the buffers. The other, more fully described in another Tempus publication, *Around Stroud, the Story Behind the Picture*, was the explosion at Whiting's grocery shop in George Street a year earlier. A domestic fire in the building spread to gunpowder stored on an upper floor, with the dramatic result that the rather faded photograph shows.

In Edwardian days, on the spot where this picture was taken, stood Redman's stationery store. At a later period the same building was a wool shop. The low, white structure in the centre of the photograph housed one of Nailsworth's longest established concerns, Yarnold's, which was an outfitter's. The Midland Bank is now, of course, renamed HSBC. It was built after the First World War on the site of Waterloo House, run by the Morris family as another outfitter's business incorporating a millinery department.

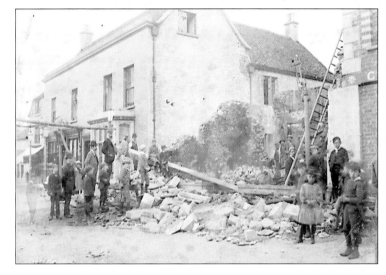

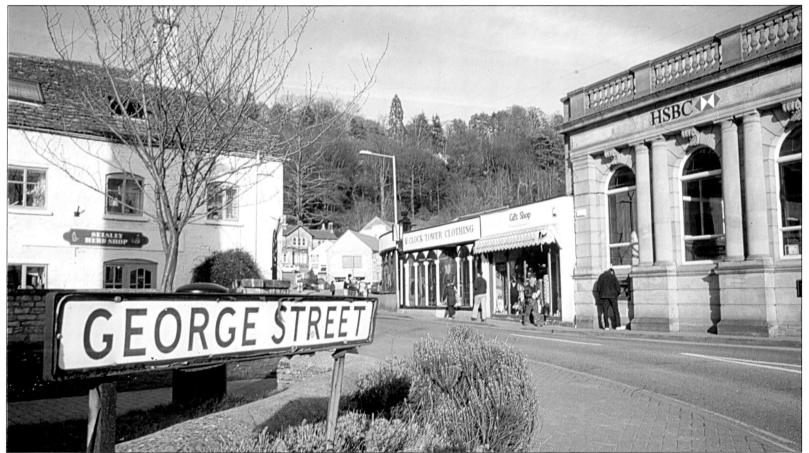

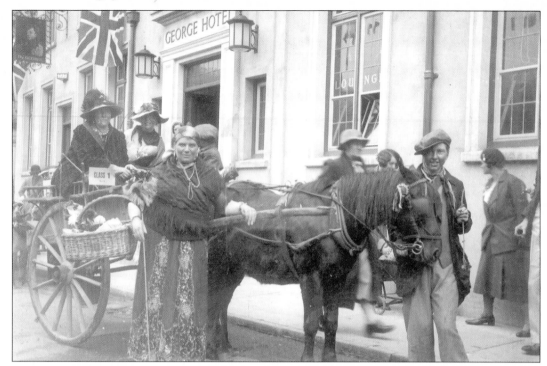

Top right:

Near the bottom of Spring Hill the Nailsworth stream flows beneath the modern roadway. Framed in the branches of a willow is George Street, with the Memorial Clock Tower, erected in 1952, to the left.

Top left:

Whether the gypsy lady photographed outside The George belongs with the horse and cart is unclear, but the occasion is certain: the Silver Jubilee Carnival Procession of 1935.

Bottom:

George Street takes on a distinctly Victorian appearance when glimpsed through the old-fashioned window of the Selsley Herb Shop.

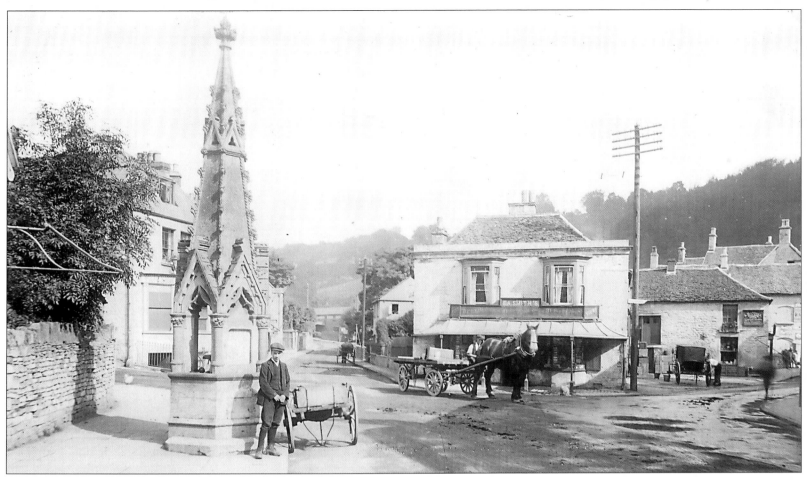

Visitors to Nailsworth – and even possibly some present-day residents – may not realise how Fountain Street acquired its name. As this photograph of 1913 makes clear, the fountain, in its original position, stood on a wide pavement a little down the street from William's Kitchen and roughly opposite the entrance to George Street.

It was erected in 1862 to honour the memory of William Smith, 'an upright lawyer', as its inscription proclaims. It was later moved twice, as we shall see, to different sites in Old Market.

The building to the left of the telegraph pole, Smith's (earlier Redman's) rather elegantly-proportioned stationery shop, was demolished some years ago. The clock tower now occupies the approximate position where it stood. The first building seen on the left in George Street housed the stables of The George Hotel.

Hidden behind the fountain is the late Victorian terrace of shops which included my maternal grandfather Lee's outfitter's business. However, at an earlier period, the Kings, members of my father's family, had also lived in the cottages which formerly stood on the same site.

One evening in the 1850s my great-great-great-grandmother, Margaret Castleman King, in her late seventies, was preparing to go upstairs to bed. Her husband, George, who was ninety, had already retired for the night when he was awoken by the smell of smoke. On going downstairs to investigate he found his wife lying unconscious on the floor, her clothes on fire. Assistance was quickly called from relations living in cottages on either side of the Kings, but the old lady was already dead. At the ensuing inquest the coroner related what it was thought had happened: the shawl Margaret was wearing had been ignited by the flame of the candle she was carrying to see her way upstairs. A verdict of accidental death was recorded.

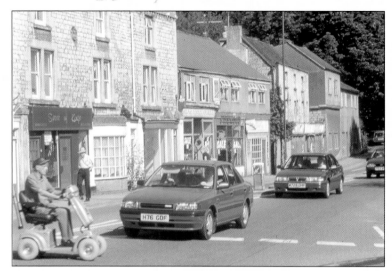

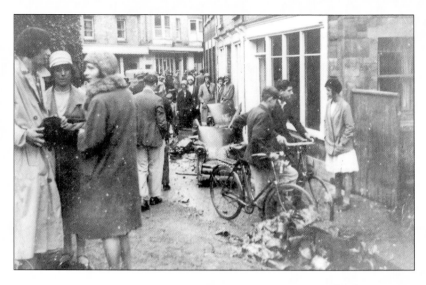

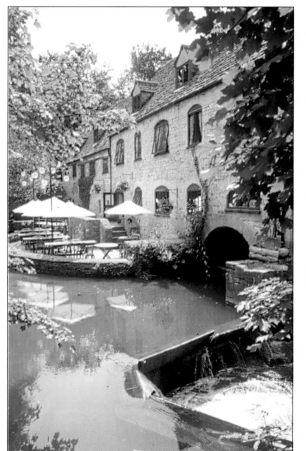

My mother grew up at a shop in the stone-built terrace in the top left picture, which was also the site of the accident with the candle.

A terrible thunderstorm struck Nailsworth in August 1931 – the worst, it was claimed, for over a hundred years. Torrential rain began at nine thirty in the evening; there was a cloudburst at eleven and the storm continued almost unabated until half past two in the morning. Huge quantities of floodwater from surrounding valleys converged on the town. Market Street, Britannia Square and Fountain Street were especially badly hit by the deluge. Contemporary newspaper accounts tell of furniture overturned and walls destroyed. A cat was rescued from one building by being hauled up on top of a small lift. Mr Powell's wooden shop front in Fountain Street was carried 150yds along the road and the postmaster almost drowned while trying to rescue important documents from the post office. Fifty hens and three dozen young chickens were killed, trapped in pens behind The Britannia Inn. Rising floodwater actually lapped over her sheets as elderly, bedridden Mrs. Walker of Brewery Lane watched helpless. She was rescued in the nick of time by Mr Ben Johnson and my cousin, Fred Newman. (Incidentally, nearly sixty years later, his widow Doris was to see further evidence of the power of water when a build-up of pressure caused by blocked underground springs resulted in parts of her house and garden in Horsley Road moving several inches down the hillside.) At Taylor's the butchers in Market Street, PC Wheeler discovered four frightened sheep which had escaped drowning by climbing on top of their manger. That nobody was killed or injured seems, in such circumstances, a minor miracle, but the events of that night have remained indelibly etched on the memories of Nailsworth people who witnessed them. The photograph above shows debris left in Cossack Square and furniture placed in the street to dry out.

In the seventeenth century Egypt Mill, left, was in the hands of Richard Webb, a clothier. Successively a dye factory and a corn mill, it is now a complex of restaurants and bars on several floors. Many historical features were retained at the time of its conversion, including two large water wheels in excellent condition.

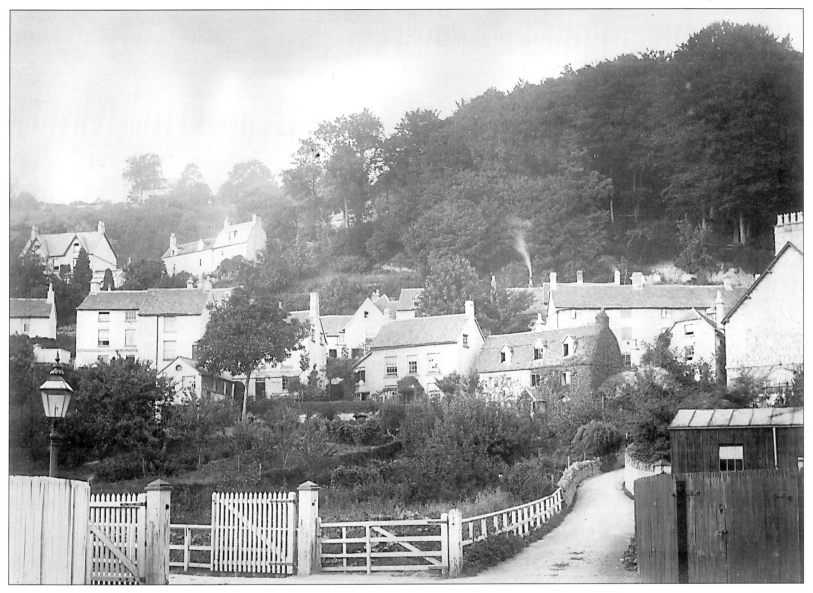

On 7 September 1901, when this picture was taken, the station was still an essential part of Nailsworth's transport system. Its gates are to the left. The near building on the right was its stabling.

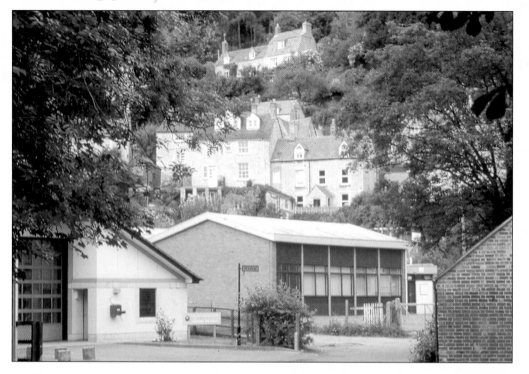

The backdrop of Watledge's attractive cottages is less visible today since the building of the new Fire Station and Telephone Exchange.

Of all surviving transport pictures of Nailsworth this is undoubtedly one of the finest. Taken around 1906, it illustrates how large a staff was needed at that period to operate the station. The youngest employee, it would seem, was not allowed to pose with his older colleagues, but still managed to be included in the picture.

Opposite page:

Nailsworth station goods yard is familiar these days as the car park for Egypt Mill restaurant. In this photograph, which dates from 1962, shortly before goods services ceased to operate, the engine shed – which was demolished soon after the closure of the line – is seen in the centre of the picture. Note also the crane. Between the engine shed and the Railway Hotel is the building occupied by C.W. Jones's coal business. His name is still visible on its façade today.

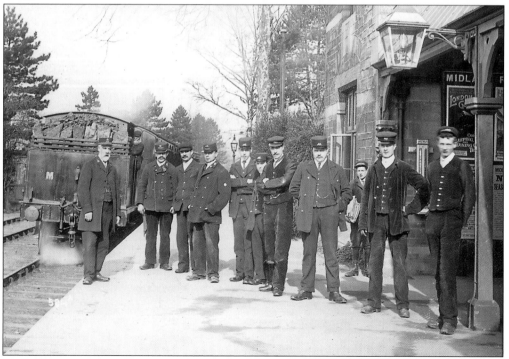

In June 1947 the last regular passenger train from Stonehouse to Nailsworth completed its final run. Known affectionately as *The Dudbridge Donkey*, the little train had ferried local people along the valley since Victorian days. Mr T.M. Sibly, of Wycliffe College, thought the occasion sufficiently momentous to allow sixty of his pupils to accompany him on the last trip.

After 1947 the odd 'Special' did visit Nailsworth occasionally. One such event took place in August 1956 and was reported in the local press under the heading 'Afternoon out with 41748'. The event depicted here was organized by The Stephenson Locomotive Society to celebrate the centenary of the Coaley to Dursley branch line.

Nailsworth's Midland railway station building has been sensitively restored as a private dwelling house. Many original features have been retained.

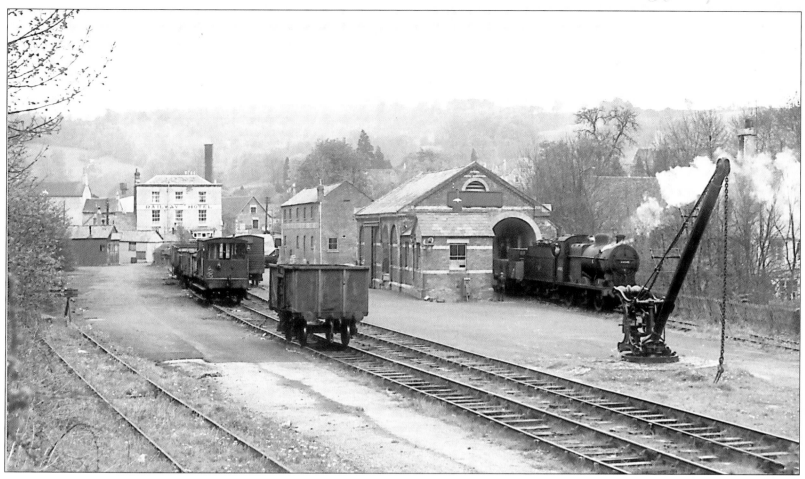

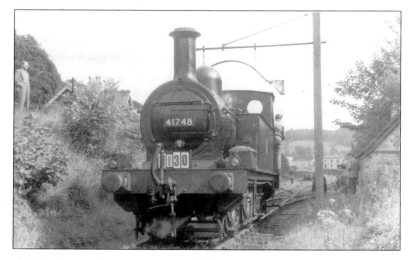

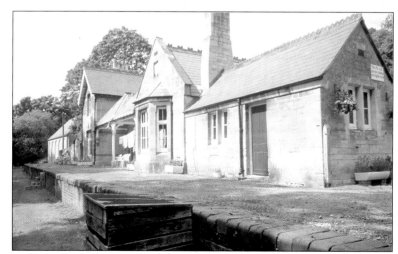

Right:

Across Bridge Street, a short distance up Spring Hill, is The Lawn, now renamed Winslow House because it was the childhood home of the real-life boy upon whose story Terence Rattigan based his celebrated play. The family later moved to Woodchester. The building is of some antiquity and was enlarged and re-fronted around 1800 by the architect Nathaniel Dyer (not to be confused with the cake-vendor of the same name mentioned earlier). In 1833 Dyer was buried in the garden of the house in order, so the story goes, to prevent his brother dancing on his grave. The watercolour of The Lawn was painted in the 1850s.

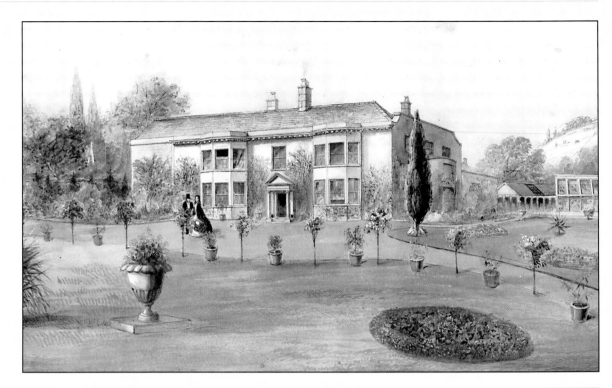

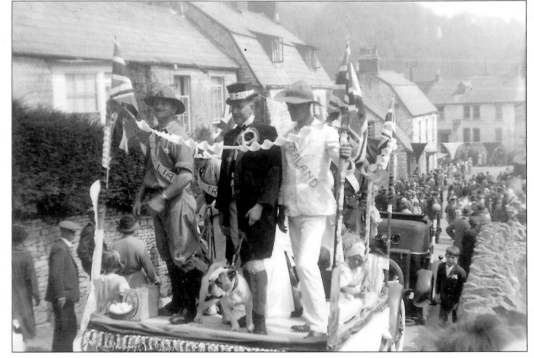

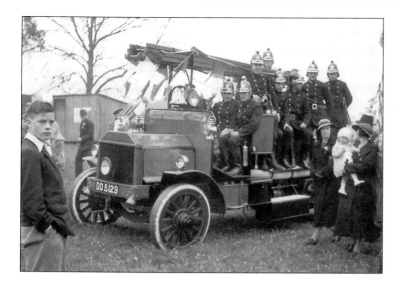

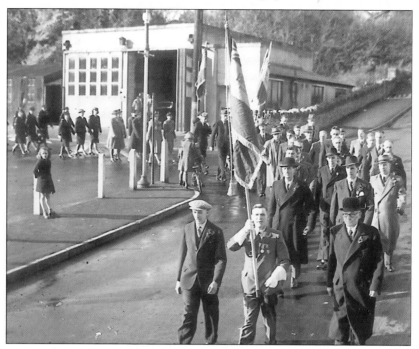

Opposite page, bottom left:

Spring Hill contains several interesting houses with fine architectural features.

Bottom right:

At the age of fifteen, Lionel Bathe photographed the 1935 Silver Jubilee Carnival procession passing down Spring Hill. The float shown here depicts representatives of various countries within the Empire. Note John Bull, with an appropriate canine companion at his feet.

This page, top left:

Nailsworth's first two fire engines were acquired in 1805. A third was purchased in 1819. By the end of the nineteenth century the Nailsworth and Woodchester Valley Voluntary Brigade owned five machines. The company was merged into the National Fire Service in 1940. The engine seen here, probably converted from a First World War vehicle, was acquired in the 1920s. It is well polished and looking its best, with its complement of retained officers, at a charity event.

Top right:

The 1947 Remembrance Day procession leaves Old Market from Spring Hill. Dick Shelton is the leading standard bearer, flanked by Leslie Woodward (left) and Mr Timbrell (right). Ronald Woodward, whose recollections of Nailsworth have been so useful in the compilation of this book, is the middle of the three men following behind in trilby hats.

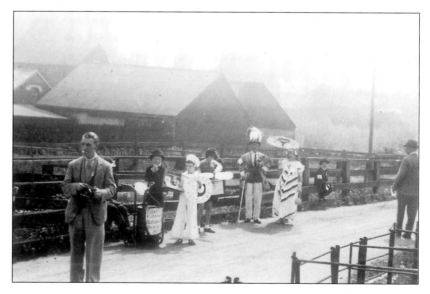

A cattle market was first established on the site of the present-day Playing Fields in 1865. It later moved to what is now called Old Market and finally closed in 1931. This photograph is another from the time of the Silver Jubilee in 1935 and shows the cattle and sheep pens then still in position.

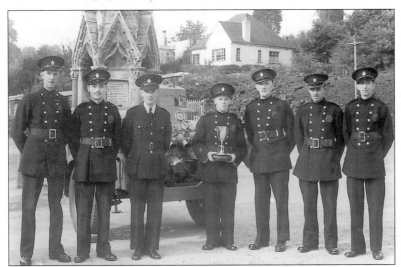

This picture is believed to have been taken in 1944, near Nailsworth's original Fire Station in Old Market. The fireman on the left is Fred Newman, whose bravery during the 1931 flood was mentioned earlier. The photograph records the Brigade's success in winning an inter-station competition. This apparently involved several teams each, in turn, attempting to empty water from the same tanker in the fastest time. The engine in the background is a Beresford Stork model, capable of pumping 350 gallons a minute. Note that the fountain is by now in its second position, where it was placed just before the last war.

In the mid-1960s it was necessary, for reasons of traffic flow, to move the fountain to its third – and, hopefully, final – resting place at the edge of Old Market. A cyclist pauses to watch the demolition of the lowest section of the structure.

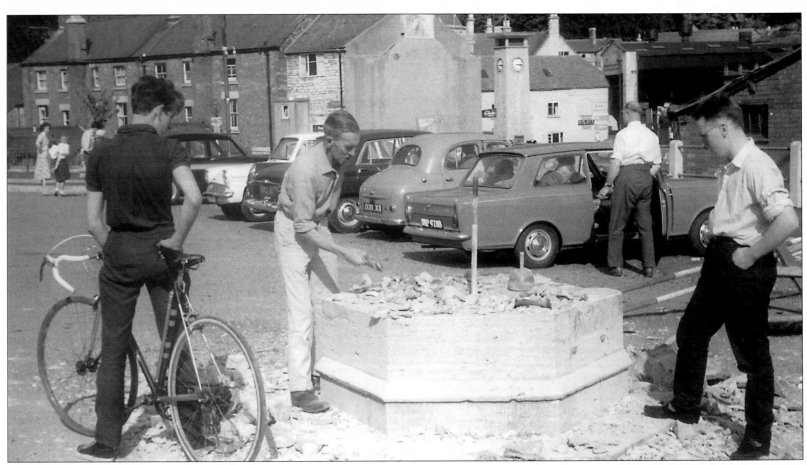

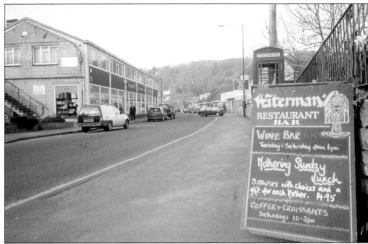

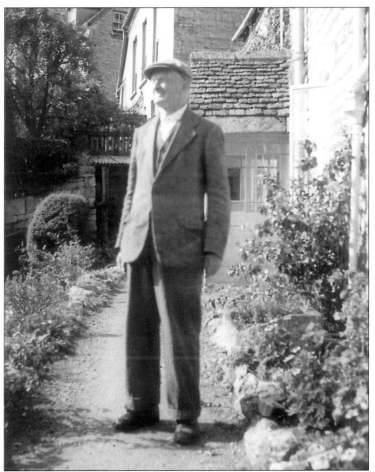

Above:

With its shops, post office and public library, Old Market is a busy area of the town.

Top right:

Bruton's ironmonger's business was formerly in Cossack Square. Waterman's restaurant, housed in an interesting old building, offers an atmospheric setting in which to enjoy fine cuisine.

Attached to the library is the Mortimer Room, a venue for meetings and exhibitions. It was built with money bequeathed to the town by William John Mortimer, pictured right, a bachelor, who died in 1970 at the age of ninety, leaving his entire estate to Nailsworth UDC, 'to use as they saw fit, for the benefit of the local inhabitants'. A shortlist of twelve possible projects to be funded through Mortimer's generous bequest was drawn up. Apart from the Mortimer Room, the other scheme chosen was the creation of the Mortimer Gardens. Since he was an avid reader, keen student of local history and enthusiastic observer of plants and trees, it was felt that these twin memorials to him admirably reflected his interests. As a footnote, it might be added that William Mortimer was a humanist. My mother claimed that his discussions with my grandfather Lee were the reason why the latter stopped attending Shortwood Chapel.

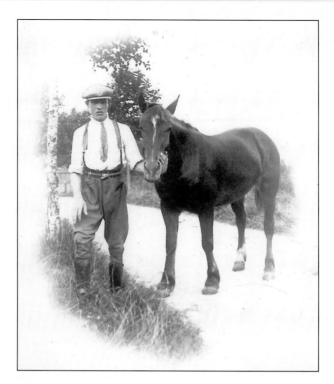

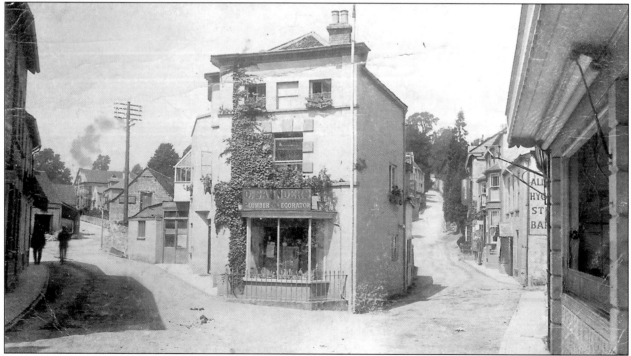

Top left:

The cat mural in the distance acts as an interesting *trompe l'oeil* in a blocked-up window of Waterman's restaurant. The buildings on the left, including the old bakery, present an attractive row of frontages.

Top right:

Walter Pearce, who worked for the bakery around 1915, and Twink, the delivery horse, pose for photographer E.P. Conway.

Bottom:

The island of buildings which formerly stood in the centre of Cossack Square was occupied by Osborn Saunders' plumbing business and the stables for Allway's bakery, which can be glimpsed on the right of the picture.

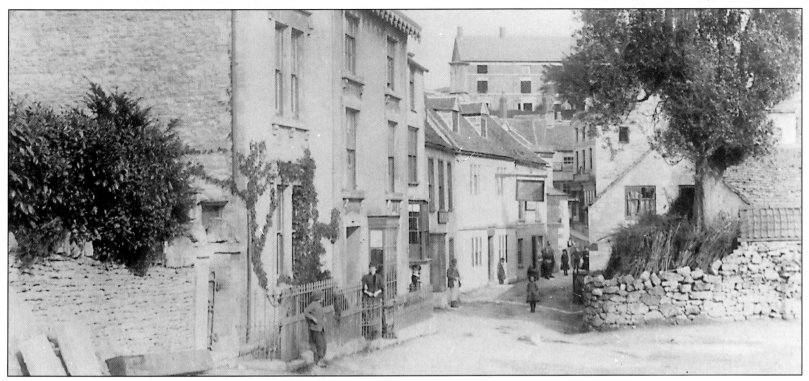

From Old Market we can, of course, nowadays pass through into Cossack Square. This was made possible, some years ago, by the demolition of the New Inn, the sign for which is clearly visible on this 1890s photograph. The shop on the near side of it was Allway's Hygienic Steam Bakery and the man standing outside in the white apron is probably my great-grandfather Samuel Allway (1835-1896), who founded the business some time in the mid-nineteenth century. The firm continued to be run by his widow, who lived to be ninety-five, and it remained a bakery until comparatively recent times. A speciality, I gather, was bread baked in cabbage leaves. I was told some forty years ago by my great-uncle, Cecil Weight, who was in Samuel's Sunday School class in the 1890s, that youngsters at the Chapel, amused by his surname, gently mocked his religious fervour by whispering behind his back a verse from Philippians, Chapter 4, 'Rejoice in the Lord, alway…'

Stokes Croft appears to date from the early eighteenth century, but probably incorporates an older structure. It is undeniably one of Nailsworth's most beautifully proportioned buildings, seen at its best since the demolition of industrial premises to its left. In the 1960s it was divided into flats for the elderly. One Sunday in 1963 my great-aunt, Eva Allway, who occupied a room on the top floor, rose and started preparing breakfast before setting out for church. She turned on the gas to make a cup of tea, but failed to remember to light the ring. Having no sense of smell, she was unaware of what had happened and was discovered dead a short while later.

Right:

In Chestnut Hill stands the Friends' Meeting House, Nailsworth's oldest religious building, which became a place of worship in 1680. George Fox himself is known to have visited the building. A more attractive entrance courtyard it would be hard to imagine and, both internally and externally, the Meeting House itself is a building of great charm. Occasional events have taken place in front of it, such as the 1956 Women's Institute market shown here.

Below, left:

The picture of a child on horseback, probably a Clissold, was taken in the stables of Chestnut Hill House around 1900.

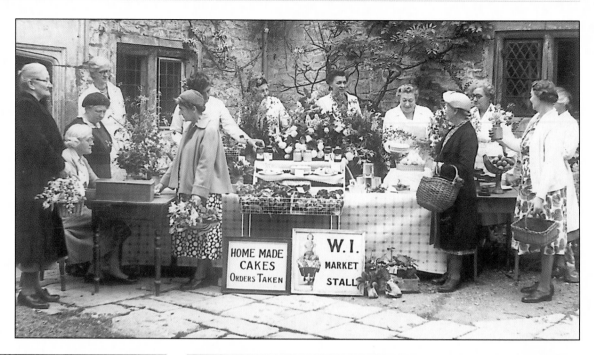

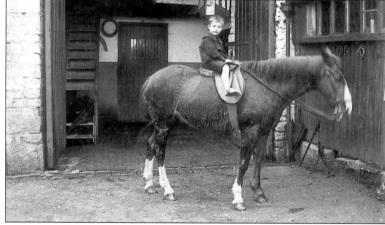

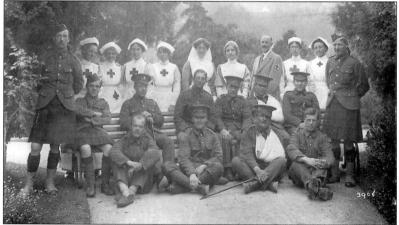

Above right:

Chestnut Hill House was, for many years, the home of the Clissold family who, curiously, were both pillars of the Baptist Church and also ran Nailsworth Brewery. W.G. Clissold was elected first chairman of Nailsworth Urban District Council in 1894. It is clear that he was highly regarded since, in 1898, a public dinner was held in his honour, in recognition of his service to Nailsworth. This is also reflected in his gift to the town of the wooden clock tower (mentioned earlier) which stood for many years on the bank next to the church. It had been expected that the tower would be temporary and serve only until the church tower was completed. As it was, however, it remained in use for half a century, until the present clock tower in Bridge Street was built. By coincidence, the illuminated address presented in 1898 to W.G. Clissold, containing the signatures of 120 Nailsworth townsfolk, was rescued a few years ago from a local junk shop, when Chestnut Hill House was sold. The photograph shows the garden of the house when it was a VAD hospital in 1915. The building was later used as a school, Danecourt House.

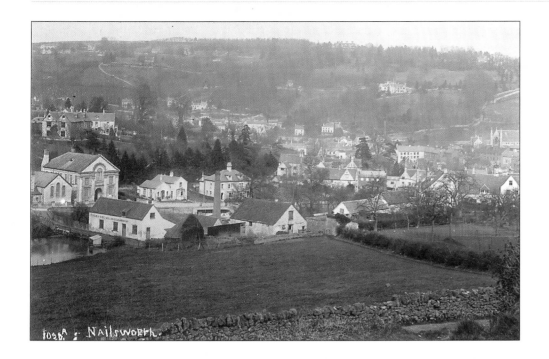

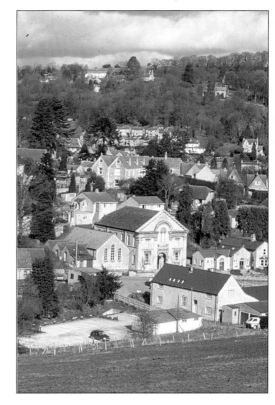

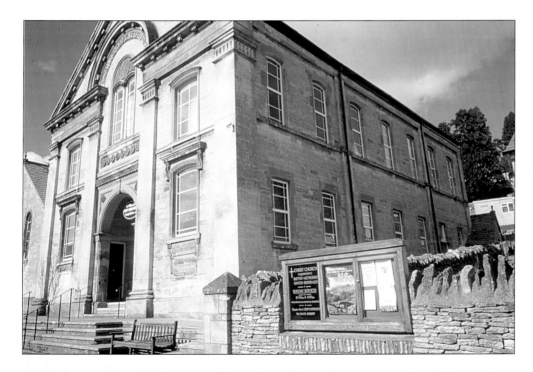

From the top of Chestnut Hill, via The Roller, a footpath led down to Shortwood Baptist Chapel. E.P. Conway's postcard view of this part of Nailsworth was taken from Shortwood Road around 1910. To the left of the chapel is the schoolroom and to the right the Chapel Parlour, now Christchurch Rooms, and the caretaker's cottage. As stated earlier, the chapel was re-erected on this site in 1881. Its architect was Mr Wills of Derby and it was built by Walter Smart of Stroud.

The view above of Christchurch, as the chapel is now known, also taken from Shortwood Road, provides an interesting contrast to E.P. Conway's view of almost a century earlier.

Christchurch is a well-designed building with many interesting architectural details, as the photograph on the left illustrates.

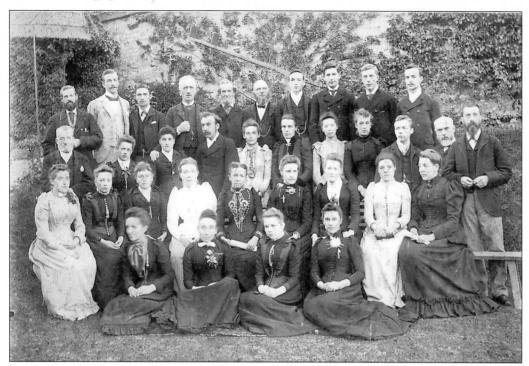

Some excellent group pictures of people associated with Shortwood Chapel have survived, mostly thanks to the Newmans, in whose family archive they were preserved. The choir photograph reproduced here was taken at Newmarket House and dates from the 1890s. My grandmother, Rose Allway, is second from the right in the front row. Her brother and two of her sisters are also present. The organist and choirmaster, Mr Antill, is fifth from the left in the back row and the pastor, Revd Arthur Nickalls, fourth from the left in the second row from the back.

This second, less formal, Shortwood Chapel group picture is Edwardian and shows a relaxed party enjoying a picnic, it is thought, on Minchinhampton Common.

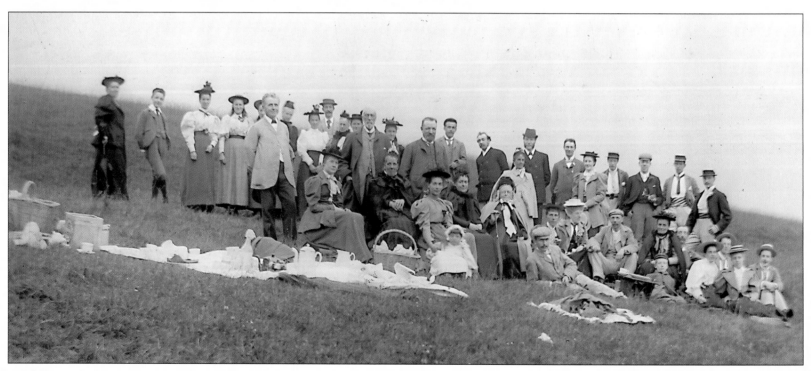

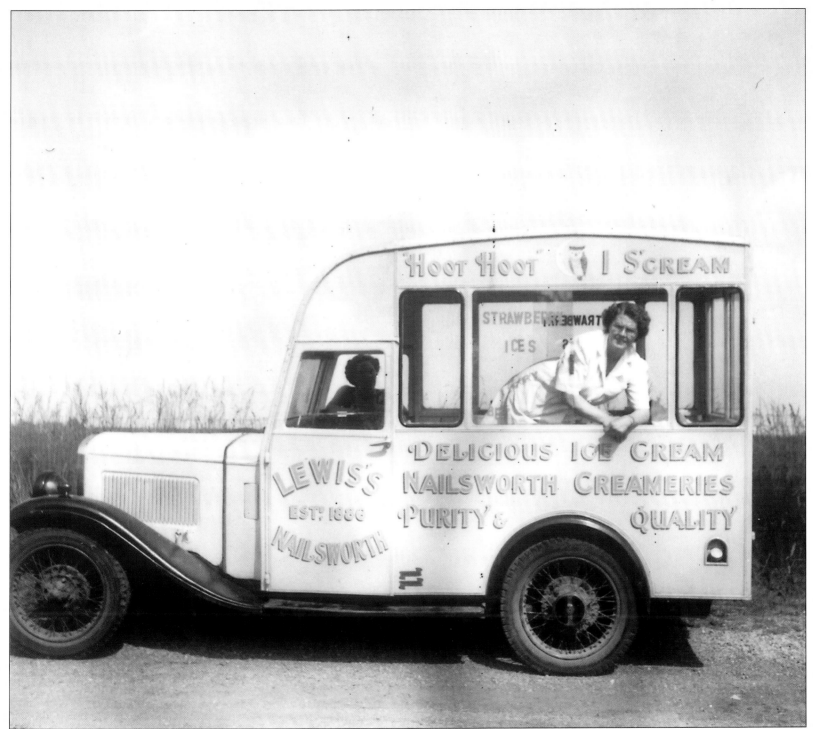

Previous page:

After taking the footpath past Barn Close our route descends into Horsley Road. At its junction with Brewery Lane is the building which will be remembered by most older residents as the premises from which Lewis's ice cream firm operated.

John Lewis established his business in 1886 at Forest Green. There were no cones in those days and ice cream was sold in returnable glass 'licks'. At first a horse called Dobbin pulled Lewis's ice cream cart. Later, bicycles and motorcycle side-cars were used before being superseded by vans. The firm moved to Brewery Lane in 1924, where ice cream was made in a twenty-gallon drum in outbuildings behind the house, then cooked by gas, cooled and frozen. The drum capacity was later increased to seventy-five gallons. Four generations of Lewis's ran the business before it closed just a year short of its centenary. The photograph is of a Lewis's van around 1970.

Here, in the house Lewis's later occupied at the junction of Horsley Road and Brewery Lane, my father was born in 1901. In the distance, on the Bath Road, is Wycliffe Terrace, my mother's first home: parental birthplace alignment!

Nailsworth's first known royal visitor was Queen Mary, who spent much of the Second World War as a guest of the Duke of Beaufort at Badminton House. She is seen here in November 1943 with Mr B.W. Johnson, while visiting his factory in Brewery Lane. The entire workforce has been gathered together for the photograph. Several curious bystanders have also managed to be included in the background. Security for the royal visit appears to have been a sole police officer. Her Majesty, we learn, stayed for an hour and a quarter and took tea with the girl employees.

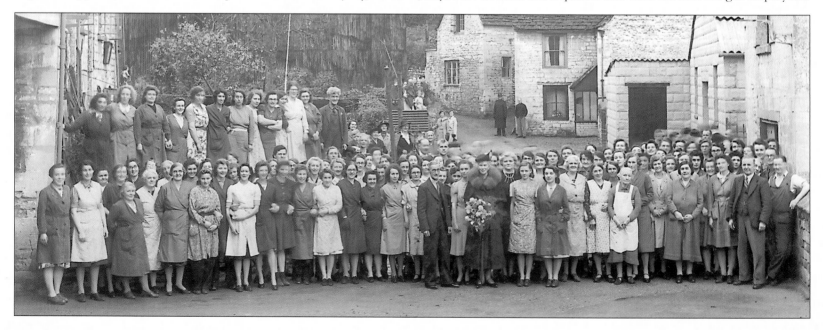

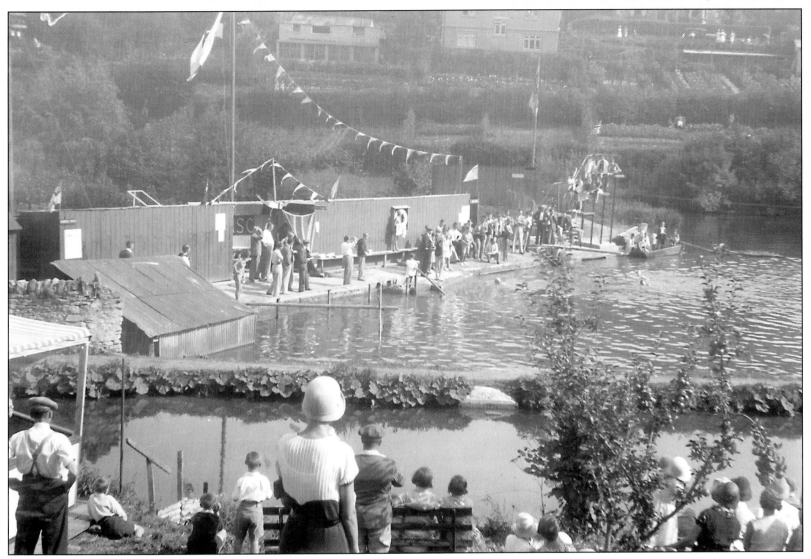

The millpond by Johnson's factory was used, for many years, as Nailsworth's open-air swimming pool. Around 1912, my mother learned to swim in its somewhat muddy, eel-infested waters. Several excellent photographs, of which this is an example, exist of 1930s galas, with spectators seated on bank-side terracing.

Beyond the seventeenth-century house occupied for some eighty years by the Johnson family is Lock's Mill where their business was based. Recently converted into private housing units, the mill was almost certainly the site, in 1802, of Joseph Lock's brewery.

Brook Cottages, off Brewery Lane, are noteworthy for their unusual windows.

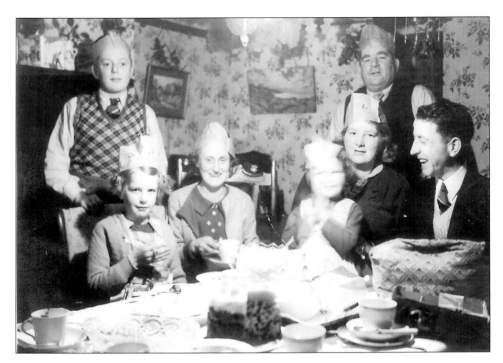

Part way along Brewery Lane is Corner Cottage, the home of Lionel Bathe, several examples of whose photographs have already appeared in this collection. Here Lionel (left) is seen celebrating Christmas 1940 with his family.

Corner Cottage has recently been sold and internally modernized. Its exterior appearance, however, remains almost unaltered.

As we have seen, so much of Nailsworth's pictorial past during the first quarter of the twentieth century was recorded by E.P. Conway, who is thought to be the photographer seen here setting up his equipment in Brewery Lane around 1920. The identification is uncertain however, and it would be pleasing if anyone still alive could verify this.

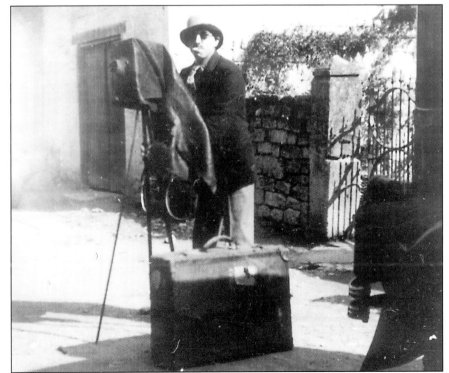

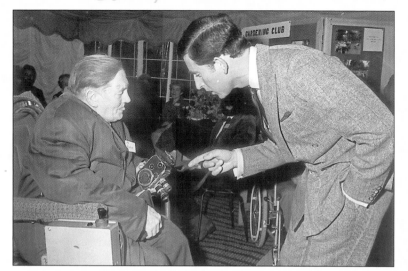

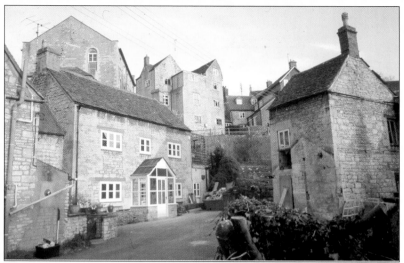

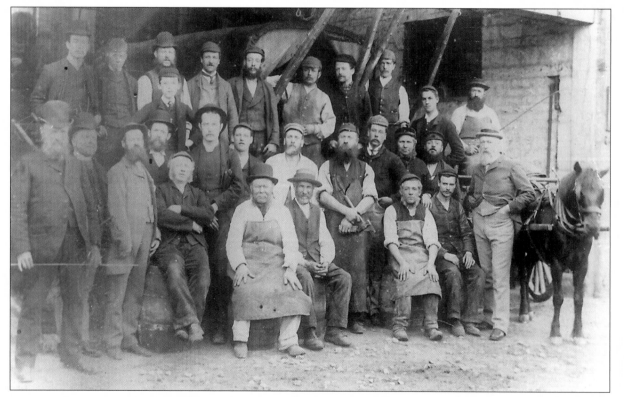

Above right:

Seen from Brewery Lane, the Town Hall and nearby buildings dominate the skyline.

Above left:

In 1986, towards the end of his life, Lionel Bathe attended a day centre at Stuart House in Minchinhampton. During a visit there by Prince Charles, Lionel explained to him how, for the previous twenty-two years, he had been recording his home town on cine film. 'The Prince was most interested in my work', he later told a newspaper reporter. 'Although I am an amateur, I am passionately keen.' Having spent a fascinating evening watching movie films at his home with Lionel and his aged mother in the late 1970s, I can vouch both for his enthusiasm and commitment.

This early picture of Nailsworth Brewery employees is from the 1890s – perhaps even the 1880s. The gentleman in the boater is W.G. Clissold, the firm's proprietor, but, unfortunately, owing to the age of the picture, it has not been possible to establish the identity of any others present.

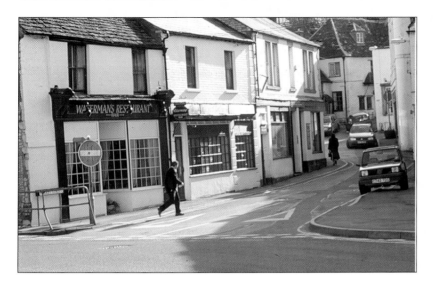

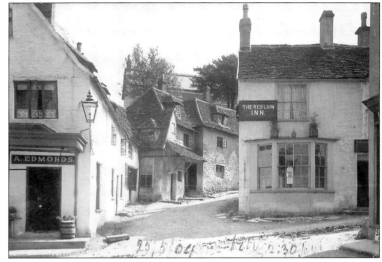

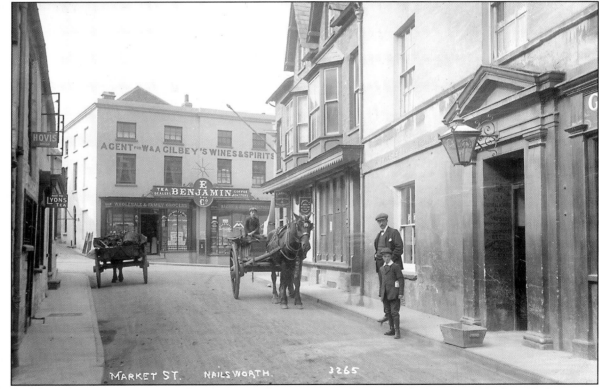

Top left:

Looking up Market Street from Cossack Square, its junction with Brewery Lane and Butcher Hill's Lane is just visible.

Top right:

There are many good photographs of Butcher Hill's Lane, but this is perhaps one of the finest. It dates from around 1904. Nailsworth Urban District Council first met in 1892 in The Red Lion, seen on the right. The butcher in question, incidentally, was very probably a distant relative of mine: seventeenth-century Hill ancestors ran a butcher's business in neighbouring Minchinhampton.

E.P. Conway's photograph of Market Street dates from around 1914 and is another of my favourite pictures. It is clear and well composed. Edward's Benjamin's grocery store is now a video shop. The gas lamp on the wall to the right illuminates the entrance to The Clothier's Arms, long since closed.

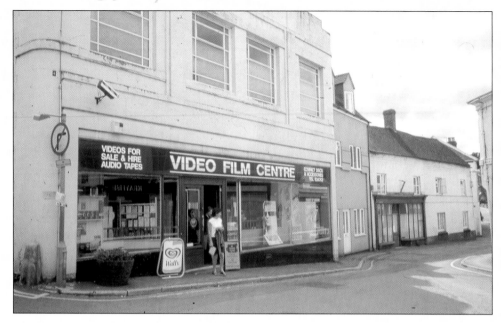

Edward Benjamin's shop still serves the needs of the people of Nailsworth but, as suggested above, in a manner he could never have foreseen.

At the top of Market Street was the King's Head, another of Nailsworth's vanished pubs. Here it is seen decorated in celebration of King George V's Coronation in 1911.

As we have learned, there have been several violent deaths among my Nailsworth ancestors: one was suffocated by smoke and another died by gas poisoning. This photograph shows the rear of terraced shops in Market Street where, in 1911, my great-uncle Samuel Dodge also met a sudden end. His death has always been something of a mystery. The official version of the story is that he awoke in the night, short of breath, opened a bedroom window for air and, somehow, fell from it to be killed on the pavement below. No-one, however, is sure what actually happened.

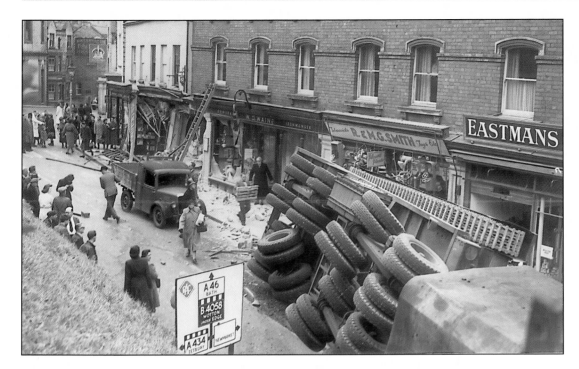

A spectacular accident occurred in Fountain Street in 1952 when a trailer carrying a 36-ton Comet tank overturned following the failure of its transporter's brakes. In the course of travelling some 60yds it completely destroyed the frontage of WHSmith's premises and damaged that of the neighbouring ironmonger's. Fortunately, when the trailer overturned, the tank remained secured to it, otherwise it would have fallen into Eastman's butcher's shop. The tank and trailer were eventually righted by attaching strong hawsers to powerful tractors parked on the top of the bank by the church entrance. Amazingly, apart from a lady working in WHSmith's, who suffered from shock, no-one was even slightly hurt. It was considered little short of miraculous that, at two o'clock on a working afternoon, there was not a single person on the stretch of pavement over which the runaway vehicle careered.

Shop fronts always make interesting photographs, since the way in which goods are displayed – not to mention the goods themselves – has changed so much over the years. This picture of Allan's newsagent's premises was taken in 1954 and shows the proprietors at that time, Barbara and Jim Allan.

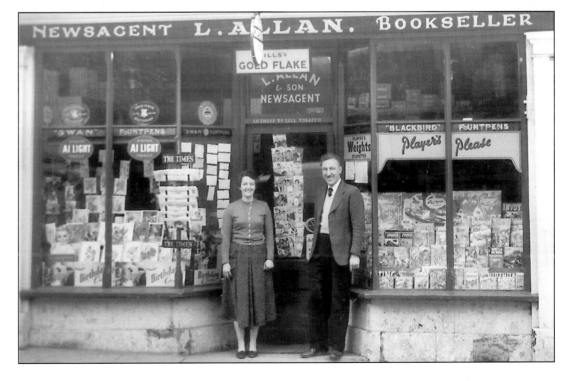

Top right:

Our journey along the streets and byways in and around Nailsworth began at the Pepperpot Church, so it is fitting that it should end at its successor. When this photograph was taken, a half-century or so had elapsed since the church's foundation stone was laid and W.G. Clissold's 'temporary' clock tower was still providing Nailsworth's citizens with the time of day. Taylor's garage had not yet been demolished and, just as in E.P. Conway's day, the church bank still offered a vantage point from which to record the town's unfolding history.

Bottom left:

As mentioned earlier, a century ago Nailsworth possessed several horse-drawn, hand-pumped fire engines. This particular one was apparently known by the irreverent, but amusing, nickname of 'Pissing Polly'.

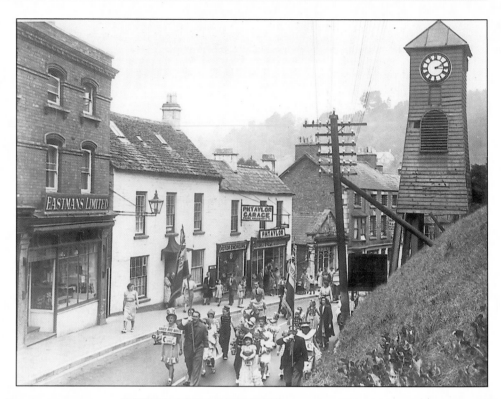

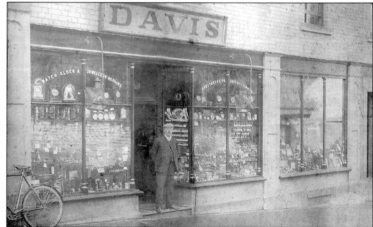

Bottom right:

Among the long-established families of Nailsworth are the Davises. Emmanuel began his clock and watchmaking business in Market Street in 1845. His son Alphonso, with the assistance of his wife Charlotte, expanded the firm to include furniture-making, moving to the Cross and finally to Day's Mill. By demolishing part of the mill the family created Fountain Street, thus joining upper and lower Nailsworth. Emmanuel's great-great-grandson Alister currently runs the business along with his father Raymond and it is now the longest-established concern in Nailsworth. The photograph shows Alphonso in front of the Fountain Street premises around 1920.